W9-CAY-987

HUNTING & FISHING
THE CHESAPEAKE

HUNTING & FISHING
THE CHESAPEAKE

Unforgettable Tales of Wing and Water

C.L. MARSHALL

THE
History
PRESS

Published by The History Press
Charleston, SC
www.historypress.net

Copyright © 2017 by Carroll Lee Marshall
All rights reserved

Front cover, top: Paul Bramble photography; *bottom*: Paul Bramble photography.
Back cover: Jim Lewis photo; *left insert*: Paul Bramble photography; *right insert*:
Paul Bramble photography.
Opposite: Joyce Northam drawing.

First published 2017

Manufactured in the United States

ISBN 9781467138338

Library of Congress Control Number: 2017948455

Notice: The information in this book is true and complete to the best of our
knowledge. It is offered without guarantee on the part of the author or The
History Press. The author and The History Press disclaim all liability in
connection with the use of this book.

All rights reserved. No part of this book may be reproduced or transmitted
in any form whatsoever without prior written permission from the publisher
except in the case of brief quotations embodied in critical articles and
reviews.

This book, like its predecessor, is the product of a life governed by the rising and falling tides of the Chesapeake Bay. Through the many distractions of family and work and the increasing race by software engineers for my attention, the relationship with the Chesapeake remains constant. It has more moods than any woman and often displays many of them over the course of a day. It can be warm and more comfortable than our favorite pajamas. Quickly it can turn as cold and unrelenting as railway steel. Yet it remains a force that quietly calls to us to explore, fish or hunt within its boundries. Memories made on the Chesapeake are the basis of lore passed down through the generations. This book is a just a glimpse into our relationship.

CONTENTS

PREFACE

L ife in the Chesapeake watershed provides opportunities that few other places offer. Hordes of waterfowl annually invade the area. The varied terrain provides a myriad of options in their pursuit. Fish, large and small, stage migration as the water temperatures begin to slowly warm in the spring, providing opportunities throughout the summer. Pelagic species from the north and south end up off the Delmarva coast at some point in the year. Few feelings compare to rolling out of a seaside inlet with thoughts of billfish and tuna dancing in one's head. There are things seen in the Chesapeake Bay and offshore waters of Delmarva that many who don't buy the ticket will only hear about thirdhand. This tiny strip of land offers those with an adventuresome outdoor bone the chance to live life. The opportunities are limited only by the imagination.

Back in my school days, folks would ask where I lived. I'd tell them, but no one understood. We'd have to show it to them on a map. The response was always the same: "What the hell do you do over there?" My answer was always the same: "Everything we want." Over the years, these same folks have come to understand just what I was talking about. The proximity of these outdoor endeavors gave birth to the infamous "Eastern Shore Grand Slam." This twenty-four-hour endeavor begins with a limit of ducks in the early morning, followed by a round of golf in the midday hours. Following golf, a limit of rockfish must be boated. The final, and often most difficult, conquest occurs often late at night: the successful consummation of the day's events with the often volatile surburban/rural female whitetail. That, my friends, is a full day.

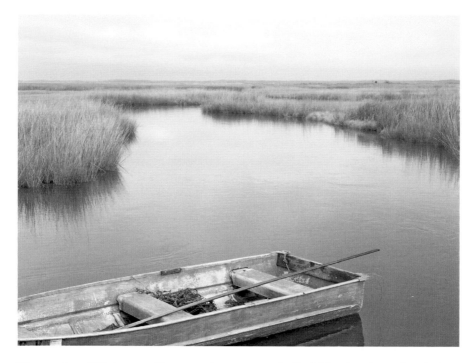

The marshes of Delmarva offer tremendous opportunity for fishing, hunting and exploring. Sometimes, small aluminum boats are just the ticket. *Jim Lewis photo*.

This book provides a brief glimpse into a life that many kindred spirits choose. It's not necessarily where, but how one chooses to live that defines a man. Many on this little spit of land choose to take full advantage of the best the Chesapeake and Atlantic have to offer. For many, these activities provide more intrinsic value than most folks could ever imagine. The value doesn't come in the form of a paycheck, it's derived from the sunrises and sunsets. It comes from the warm southerly breezes as fresh-caught dinner cooks on the open fire. It's about the sound of the surf and the anticipation of the sun's first peek over the distant horizon. It's about a successful teaser bite, a good retrieve and the smile a young hunter displays as their first goose is claimed. It's about the people we choose to share these moments with. At the root of all this is the land and the water. It's our playground. Cherish it.

ACKNOWLEDGEMENTS

There's a long list of folks who I'd like to thank for making this book a reality. These include, but are not limited to, my family, Saxis Island Museum, Paul Bramble Photography, Jim Lewis Photography, Joyce Northam Artwork, the Peninsula Enterprise and my good friends who have supported me through these endeavors. Once again, I'd like to thank Maker's Mark distillery, namely its Cask Strength product, for the courage to travel down this road once again.

A FRESHWATER SCARE

On the ride back from Federalsburg, the little ball of sunshine slept snuggled up to my leg on the bench seat of the Dodge pickup. I had been without a hunting dog for several years. We had decided on a golden retriever and found an acceptable litter in the small Caroline County town. He was selected on the fact that he was a little off-color, much different than the rest, with a darker golden hue than his litter mates. He was given the name "Gunner" by our youngest son.

My wife and I had agreed that, with young children in the house, a golden would be a good choice. With a reputation for being very loving, good with kids, playful, kind to strangers and well mannered, it appeared to be a good fit for our growing family. I hoped to capitalize on these traits and have a decent hunting dog. From the outset, the prospect of a hunting dog was somewhat in question. He showed little interest in the water and even less in retrieving. But he slowly began to develop along these lines. As far as the general traits for which we chose a golden, he certainly didn't fit any of those characteristics.

Though loving to our family and to a small circle of friends, outsiders were often greeted with a snarl and harsh inspection before Gunner began to warm up to them. He loved to play, but only with those with whom he had developed a close relationship. Of most interest, he was a very aggressive dog. He often fought with other dogs. Male, female, old or young, it really didn't matter to him. He felt a need to prove his dominance. His demeanor was more that of a Chesapeake Bay Retriever than a golden. When hunting, he used this to his advantage.

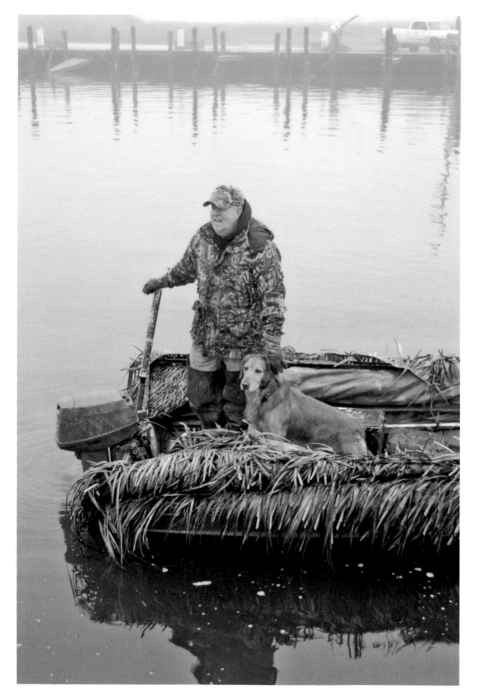

Gunner and I prepare for departure on a Saturday afternoon hunt. *Jim Lewis photo*.

There was a lot of give-and-take between me and this dog before he became an adequate hunter. He wanted to do things his way, and I was unable to change his mind. We elected to settle for compromise. I'd shoot the ducks, and he'd go get them. Gunner wouldn't hunt near the blind, electing rather to hunt from a vantage point twenty yards to the right of the blind. To that location he would take the birds he retrieved and place them in a very neat pile. He'd continue to arrange the birds in that pile when things got slow until he had them in the order and arrangement that pleased him. If the pile got big enough, and he had it stacked just right, often he'd just sit atop the pile he'd created. Those birds were continually guarded until the decoys were picked up and we were fixing to leave. He had a very soft mouth, and the ducks were clean as possible when we went to collect them. After all, in his mind, they were his ducks.

The local game wardens got to know him and how he worked. When checked, they'd ask how many ducks we had and where they were. We'd just answer and point over to where the dog was. He got to know the local wardens quite well.

We were trying to fit in a quick hunt before a 9:00 a.m. meeting in Salisbury, Maryland. Our plan was to arrive early at the freshwater farm pond to intercept the wood ducks that seemed to appear just before legal shooting time. A few mallards seemed to arrive daily right at sunup. Assorted other waterfowl used the tree-lined two-acre piece of water as they migrated though the area. Our little miracle bush blind adorned a slight point that narrowed the pond to just over forty yards. To the northwest of the blind, the pond shallowed into a stump-filled haven for puddlers of all types. We'd had several very eventful mornings there.

The retrieve began as many had before it. With his usual laid-back style, Gunner eased into the water and swam at his own deliberate pace toward the pair of ringbills that had been knocked down. One floated belly-up; the second was injured but began to swim slowly toward the opposite shore. Gunner had seen this many times before. This dog had the disposition of a Chessie and the loyalty of a Lab. He lived to kill anything that he could catch. Squirrels, cats, moles, escaped chickens or ducks—it really didn't matter to him. If it moved, he owned it. In his mind, this ringbill was next.

He was not a fast swimmer but was a very determined retriever. His focus wasn't on speed but, rather, on results. The ringbill reached the opposite side of the pond and found refuge in the bush-covered shoreline. Gunner entered this thick mass of vegetation right on his heels. The chase ensued as

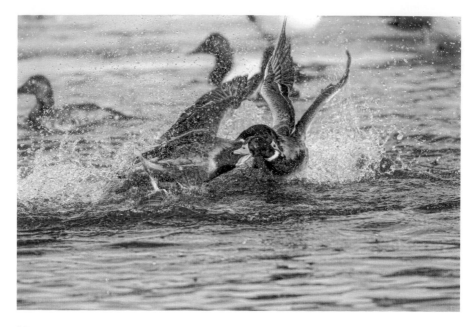

It's a very competitive environment in the wild. These two mallard drakes are seen settling a dispute over a female. *Paul Bramble photo*.

the bird dove in and out of the cover with Gunner steadily giving chase. He knew that in time he'd outlast the bird and it would be his. Persistance would pay off—and it did. Gunner began the return trip across the pond in a very businesslike manner.

Rather than coming back to the blind, Gunner looked to resume this spot to the left of the blind. He planned to add this ringbill to the pile and then make short work of the one still floating in the decoys. As he passed the point, our attention turned to four mallards circling above the tops of the loblolly pines. With each circle, they began to get lower. We called hard, with little success. I just figured the dog was in the decoys making the retrieve on the second downed bird. As the calling quit, there was a thrashing noise coming from the left.

With the ringbill firmly in Gunner's mouth, his collar had gotten caught in a branch ten yards off the shoreline. He pulled and twisted against the branch, but it would not give. The harder he pulled, the tighter his choker collar pulled against his throat. As he thrashed wildly, I could see the fear in his eyes. Things were not going well for him. We quickly abandoned our blind and ran to his aid. Standing on the shore, we called for him to pull though the stick. The harder he tried, the more of a toll it took on him.

Seeing his head briefly go under the water as he quickly tired, we frantically began to search for options. We had no boat. The metal ring of the collar was hung on a branch that must have been still attached to a fallen tree. His head went under again. Again, he fought to the surface. From ten yards, I could see my terrified friend fighting for his life. As his head went under a third time, I shed my coat and boots and walked quickly into the cold, dark waters of the pond.

The sides were steep, and it became quickly evident that there would be no wading to his rescue. Sliding down the side of the pond, I caught myself nearly chest deep. With three strong strokes, I reached the struggling dog. It was almost as if he hugged me as I reached him. It was a sweet, cold embrace. He was tired, scared and near exhaustion. His weight pushed me under the surface. I now was concerned for both of our welfare. Reaching for the branch that had him hemmed, my hand freed the choker chain from its bindings. I released him from my grasp, and he made for shore. I began to do the same. I was tiring quickly as I reached the shoreline. My partner grabbed me by the collar and snatched me out of the water onto the edge of the pond.

I wrapped myself in my hunting coat and reached for the hot coffee that had been provided for me. Gunner deposited the ringbill in the pile with the others, shook off the cold water and walked over to check on me. The choker collar was removed from his neck and replaced by my two loving arms. He wanted no part of that. There was still another bird to retrieve. He got right back to it.

AN OLD FRIEND

I was in for a new experience.

Over drinks with a friend, I'd accepted an invitation to hunt one of his impoundments. I'd heard and read a great deal about the subject but had never personally experienced it. Having seen the thousands of birds funneling into flooded grain fields near where I traditionally hunt, I must say that there was a bit of jealousy as I listened to volley after volley of shooting. Prior to making any judgements, I felt it prudent to experience impoundment hunting for myself.

Arriving at the farm, I was welcomed by the owner. After loading my gear into the Polaris ATV, we dressed in the warmth of the lodge. We moved quickly, anticipating what was to come. It was a short ride from the house to the blind. Eight flocked mallards were pulled from the blind and set toward the upwind side of the oval shooting area. Corn had been planted earlier in the year and left unharvested. Prior to manually flooding the area by use of pumps and piping, an oval shooting area was cut. Water was pumped into the basin, and traditional farmland was transformed into a legal buffet for wandering waterfowl. It was a different experience for me.

We set a pair of Higdon pulsators in the opening for good measure. We settled into the box blind, and it wasn't long before the birds began to filter back into the pond. It was hard for an old Saxis Islander to fathom that we now sat about to shoot ducks over three acres of corn—legally. Sure, some was still in the husk, but much more had fallen, been pulled off or

simply dropped to the claylike bottom of the pond. After spending much of my youth looking over my shoulder in such a situation, this was a little hard to handle at first. I quickly got over it as five black ducks circled wide, came inside the large pines to the right of the blind and set up for quick descent into our meager spread. The old man sitting to my right grinned as he watched the five hover over the decoys. Despite his advanced years, he was quick to rise to the shot. The spark was still there. It wasn't what I'd expected to see.

His old chocolate Lab, Gidget, lay by the door of the blind, taking it all in. She held tight as the shots rang out. The falling birds didn't really rattle her. She'd seen this show before. Her interest was piqued as one of the blacks swam quickly away from the cleared area toward the standing corn. Gidget watched with interest. The old man muttered something that I couldn't understand toward Gidget. At her own deliberate pace, she eased into the water, ignored those floating feet-up and made her way to where the escapee entered the maze of cornstalks. After a little zigging and zagging, she ambled out of the labyrinth with a quite lively black duck secured in her jaws. Delivering it to the old man's hand, she exchanged the bird for a treat of some sort. Without chewing the kibble, she resumed her job picking up the other two blacks in the same manner. She received two more snacks for her efforts and resumed her resting spot beside the door.

As we sat in the box, our tales and yarns flew around in the same manner as the ducks. Several times, our laughter and chatter startled mallards that had found their way into the decoys under our radar. This style of hunting was far different than what I was accustomed to. We didn't have to worry about *if* they'd come; it was just a matter of *when*. With our focus back on hunting for the moment, we watched several small flocks of ducks work our few decoys but opted for the larger open water of the adjacent pond.

Out of the thinner air, a pair of pintails locked up and began to glide effortlessly toward our spread. Undoubtedly new arrivals to Worcester County, they rode the thermal winds in a slow, downward spiral toward the spread. We got a good glimpse of the pair as one of their maneuvers brought them from the back of the blind directly overhead. The drake's tail feathers seemed to stretch out a full six inches from his tail cluster. Their long necks and slender bodies certainly lend credibility to their nickname as "greyhounds of the sky." In unison, the pair banked hard right and resumed their glide almost directly back toward the box. The shot was

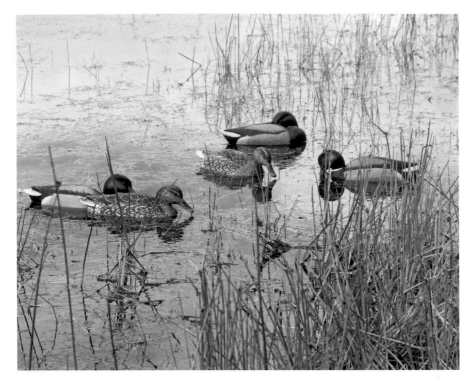

By varying the head position of the decoys, any decoy spread can be made to look more lifelike. *Jim Lewis photo.*

called at about thirty yards. The old man allowed me the first opportunity, which went unanswered. Two rang out quickly from his Ithica pump. I had no target after that. Gidget got two more treats.

December's biting winds had just started to growl. The pair of pintails were most likely new arrivals. Most likely they were moving ahead of the coming front. Their northern Delaware stopover and been interrupted by this weather event, and they instinctfully made their way south. Being just before Christmas, they were behind the bulk of their kind. Discussion turned to whether they saw the flooded, grain-filled rectangle from their migratory altitude and knew, from experience, that areas like this provide safety and food and serve as a good place to roost for a couple of evenings. Their ticket was one way.

Mallards filtered in and out of shooting range. Occasionally, we'd rise to shoot, and Gidget would do her thing. For a treat, of course. After a couple hours of shooting the bull, shooting at ducks and sipping now and again on Worcester County's finest homemade peach brandy, we had filled our

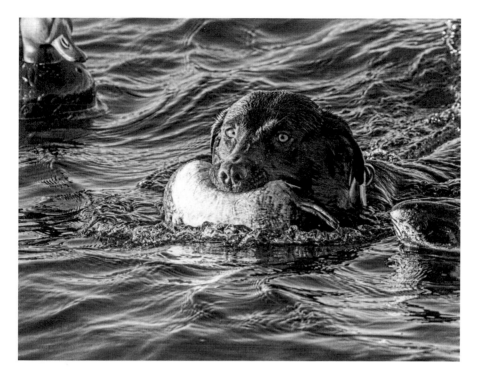

Watching your retriever fetch downed game is one of the greatest pleasures a waterfowler can witness. *Paul Bramble photography*.

limits. The decoys were pulled and stacked back in the blind. The pulsators were placed back into the ATV to be recharged for the next outing. We agreed that it would be the following afternoon. With that decision made, we went our separate ways for the evening.

At 1:30 the following afternoon, I rolled up to the old man's house. It would be four of us on this windswept afternoon. Northwest winds gusted occasionally to twenty-five miles per hour as the temps hovered in the mid-thirties. We agreed that this might be our last chance to get after the strong population of green-winged teal that were visiting the flooded wheat on a regular basis. I quickly threw my gear in the back of the ATV and ducked into an old chicken house turned gunning camp to gear up. Brian Riley, Alan Carter and the old man were nearly ready. From their sense of urgency, I could see they expected an eventful afternoon. Gidget was ready to go.

After we arrived at the blind, the setup was very quick. A couple dozen Texas rigged teal, six mallards and half a dozen blacks were haphazardly

tossed in the wheat stubble. Rigged with only three feet of line and a four-ounce sliding egg sinker, the setup was remarkably easy. Brian and I tended to this chore while Alan and the old man got things right in the blind. We hadn't gotten back to the blind before the first shots rang out. A pair of blacks escaped. Two did not. As the door was pinned shut behind us, five teal rocketed across the decoys. They did not return, as our commotion disturbed their plans.

From the south, cresting then dropping below the pines, a flock of twenty-five teal had plans for dinner at our little piece of flooded wheat. As they caught a quartering wind, we were mere seconds from calling the shot when, following the same flight plan, a knot of seventy-five had plans to join the fray. Brian and I saw them, Alan and the old man did not. The twenty-five sat nervously at first and almost immediately relaxed, then began feeding. They'd been there before. Our gunning partners watched the first visitors, hoping that Brian and I hadn't been wrong in calling off the "bird in hand" shot. Seconds later, we had more than one hundred teal on the water. With the exhuberence of a man fifty years his junior, the old man whispered, "I got 'em in a pile. Let's whack 'em." We unleashed hell on the unsuspecting birds. Twelve shots rang out very quickly. Brian, the old man and I each held a pair of extra shells in our teeth; these were quickly thrown into our autoloaders. These extra six shots picked off three late departures and capped a pair of cripples.

If the shooting was chaotic, the next ten minutes were insane. The pond resembled a Civil War battlefield. There was a distinct smell of gunpowder in the air. Many were dead. Gidget was busy returning crippled birds back to the old man in exchange for kibble. Brian and I were slashing through the shin-high stubble wringing necks of cripples and dispatching those trying to make a last-ditch escape. By the time all the dust had settled, a good-sized pile of teal was stacked by the blind. Gidget wandered through the stubble, thinking that there must be more in there somewhere.

Alan went to fetch the ATV while Brian and I sleeved our guns and began to retrieve the decoys. The old man's eyes told the story. Gidget added a couple more to our pile to his delight. Back in the chicken house/gunning club, the pure thrill the old man got out of gunning on his own property was evident. He was proud of the habitat he'd created and found joy in sharing it with his friends.

It was the last time we'd share a blind together. Within a few months of this hunt, the old man passed away working on one of his tractors. He went out the way he lived his life: dirty hands, working and enjoying what

he was doing. We now return to his farm at least a couple times each year to honor the old man's memory. Sometimes we'll hunt, but it's just not the same. Many times, we'll just sit in the blind and sip on some peach brandy. Good gunning partners are always remembered fondly.

BALDPATES AND SEAHORSES

Sitting in Wolf's Sandwich Shoppe in downtown Atlantic, Virginia, my mind was firmly focused on the cheesesteak sub that Ronnie was whipping up. It'd been a long morning, the result of a long prior night, and this concoction he would soon produce at the service window should be the key to surviving the afternoon.

While waiting for my ticket to be called, I chatted with the usual suspects about recent hunting or fishing exploits. As my number was called, our conversation took a hiatus. They could see that my priorities, at the moment, had shifted. Their conversation continued as I devoured the sandwich. With the first half of it consumed, my day took a turn for the better.

Offhandedly, I asked Benjy Thomas if he'd seen any baldpates. He revealed that he had a good number of them using in one of his freshwater ponds bordering Boggs Bay. I knew the pond he spoke of and had longed for the opportunity to gun it. After a little conversation, we planned for an afternoon hunt the following day. I finished my sandwich, paid my bill and set out on my way.

The following afternoon, we met at his farm at the appointed time. Temperatures had dipped into the low twenties the night before. The daily high hadn't gotten much above freezing. Overcast skies and a gentle northwest wind set the scene for a memorable day on this little seaside pond. He'd had a fairly busy night and morning, as his chickens had just gone out. I asked if he'd been down to the pond to check it out; he said work had prevented it. We both were excited to see what the afternoon would bring.

The gear was loaded in his truck, and we eased down the farm road to the north side of the pond. Having no idea what lay in store, I just followed along. I was on his turf, and I was a guest. Arriving at the pond, we tossed our gear into his fifteen-foot handmade wooden skiff. The old Johnson Sea Horse 20 outboard would provide the push to get us to the blind located on an island in the middle of the pond. The cold temps had left a layer of windowpane-thin ice across most of the pond. We felt this should only help us. His blind was located such that the ice had pushed off from the island. We tossed over a dozen decoys and settled in the blind for the afternoon's activities. It didn't take long to get started.

The first customers came as a pair. The two mallards, a fat drake and a chatty hen, circled once and fell right into the decoys. Benjy claimed the drake. Two blasts from my double failed to find the hen, and she escaped just as she had arrived. Quacking loudly as if to rub in my poor shooting, she was last seen crossing the tops of the loblolly pines bordering the pond to the east. As I was getting shooting tips from my partner, practicing shouldering my gun and chastising myself about what had just happened, five baldpates materialized from nowhere. We didn't even get to enjoy the aerial display that they normally provide. They were on us quickly. There were two survivors.

The temperatures steadily dropped over the afternoon, and the increasing moisture in the air beckoned the coming snow. Ice steadily knitted around our little island. Our shooting hole got increasingly smaller. As we began to discuss how long we should stay, we were interrupted by three black ducks backpedaling over the decoys. The right and left ducks fell simultaneously. We double-teamed the middle bird, thwarting his escape. With the three blacks on the water, it seemed like a good time to get out of there. Ice had surrounded our outside decoys. It was only going to get worse.

We fired up the old Sea Horse and made our way to the decoys. They were cleared of ice and gingerly placed in a wooden box in the bow of the boat. Floating feet-up, the three black ducks were placed neatly across the decoys, joining the mallard and baldpates. It had been a very eventful hour. With our gear properly stowed, Benjy turned the boat toward its home. The pond was full of stumps, so it would be a slow ride. The ice introduced a variable that neither of us had planned on.

The windowpane glass that we had skirted over on the way out had gotten noticeably thicker. There was concern on Benjy's face when we began to slowly push our way through the sheet ice. The chunks of ice made by the sharp bow tumbled below the floor of the boat. The small outboard strained and jumped as the lower unit and prop came in contact with the

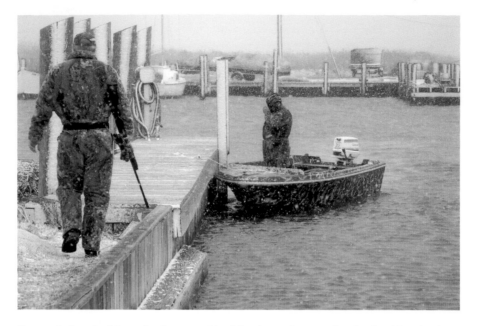

Snow, wind and cold weather have combined for the perfect gunning day for this pair of Saxis Island hunters. *Jim Lewis photo.*

hardened ice. Our worries about the ice eating through the wooden hull of the boat were quickly outweighed as the motor began to rev at a high rate but provided no forward propulsion. Outboards of this generation had a metal pin that provided the linkage from the gear case to the prop. In the event that the prop got hung on something, the pin would break rather than doing major damage to the gearbox. Sure enough, we'd broken one.

Quickly Benjy produced one and replaced it with the skill of a master mechanic. In less than five minutes, we were back in business. As the boat edged forward, the ice began to take its toll on the wooden hull. It was inevitable that the ice would find its way inside the boat before we got back to the truck. I manned a five-gallon bucket just in case. Another shear pin broke. We were stranded 150 yards from the warmth of our truck, searching for another shear pin. We had none. With a pair of pliers, I began to fashion one from the wire handle on the five-gallon bucket I was holding. After some sizing issues, we got it installed and began to slowly make progress.

The soft metal of the bucket handle wasn't the ideal material to use, but it was all we had. The first attempt failed after about fifty yards. Yet another was cut from the handle and installed. As the boat lurched forward, the first piece of ice appeared on the inside of the skiff. With it, water began to

trickle in. Another fifty yards of progress, another shear pin failure. A third makeshift shear pin was cut from the wire handle. Now we began to wonder if we'd have enough metal in the handle to make it to the bank. As he spun the hub on the installed third pin, we made the decision to get to the nearest land rather than back to the truck. Turning to port, ice had pushed its way through the starboard side of the wooden skiff. Our situation was now grave. Water was coming in the boat quicker than I could evacuate it. Pushing through the ice with increased force resulted in another shear pin breakage. We still had another fifty yards to get to safety. The last of the "five-gallon bucket handle" shear pins was installed as I pumped the cold water and ice out of the boat with a feverish pace.

Benjy was getting pretty good at installing shear pins. In seemingly no time, he had us back up and running and heading for the nearest dry land. Somehow, the last one held until the boat's nose met terra firma. The decoys, gear, ducks, gas tanks and, finally, the motor were removed from the boat and tossed hurriedly onto the bank. Benjy hightailed it to the truck as the boat began to fill with water. Upon his return, the bowline was attached to his trailer hitch and the water-laden boat was dragged out of the pond.

Though we were certainly aware of the grave predicament that we had been involved in for the last thirty minutes, we were too busy trying to keep moving and stay afloat to think about the danger we were in. It wasn't until we had everything loaded in the back of his truck that we took stock of what had just occurred. It could have been bad. It could have been very bad. A little redneck ingenuity combined with the mechanical skills of a man who had grown up fixing things on a family farm had combined to save our skins one more time.

Bouncing along the old dirt road back toward his house, we rehashed the events of the day. The discussion didn't revolve around the perils we'd faced, including the ice cutting through the wooden hull of the skiff and the shear pin issues. We spoke of the baldpates dancing in the gray winter sky. We heckled each other about shots made and missed. We spoke of the preparations we'd have to make before our next adventure and how lucky we were to live on the Eastern Shore of Virginia.

4

SMALL CRAFT WARNINGS

The erect dorsal of the six-hundred-pound blue marlin accelerated quickly as it zeroed in on the horse ballyhoo swimming very lifelike behind a large black-and-purple Islander. I stood in amazement at the force with which this very aggressive beast attacked her dinner. There was no need for a feathered drop back of the bait. She hammered the bait from the port side, accelerating as she swatted it with her bill and engulfing it quickly, leaving a shower of ocean water and a hole the size of a VW in her wake. I was glad to be at the helm.

The day dawned as expected. For once, all the prognosticators were on the same page, mentioning light winds from the south. They all also used the word "variable," which to us was the signal to pull the trigger on a tuna trip. They'd been catching a few at 26 Mile Hill out of Wachapreague. The thirty-fathom lumps just inside the Washington Canyon held many more. A combination of an excellent forecast, favorable sea conditions and several other boats heading to the same area made me and my fishing partner Bill Hall anxious to put his nineteen-foot Swan Point, dubbed "Fishmaker," to the test. We intended to use all of its sixty-five-gallon fuel capacity.

To this point, the Swan Point had been an excellent fishing platform. We'd made several trips out of Chincoteague and Wachapreague for sea bass and tautog. It had performed admirably in the shallows off Elbow Tump for speckled trout and seemed to attract red drum down at Parker's Island. We had made several trips down to Cape Charles, catching limits of black drum on each trip. A fifty-two-inch cobia was found minding his own

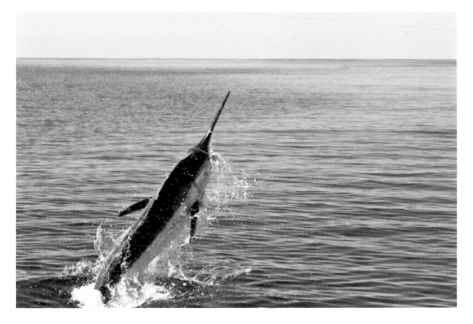

Images such as this tail-walking blue marlin are emblazoned in the minds of many offshore anglers. It's what brings us back time and time again. *Jake Graves photo.*

business swimming under a sea turtle. He was tricked into eating a yellow bucktail and subsequently released after putting up one hell of a fight on light spinning tackle. At this early point in the year, we had collected enough Virginia Saltwater Fishing Tournament plaques to use as placemats for a dinner service for eight. Things were going well as we moved into late June.

We had been looking for a weather window for some time to put some tuna blood in her floor. There was a good chance that we'd be able to find some bluefins at the Parking Lot in mid-July. The combination of weather, good numbers of mahi and the occasional yellowfin tuna at the "hills" would lure us and a few others to traverse the thirty or so miles to a sea mount off the Wachapreague, Virginia coast. Our destination would be 26 Mile Hill.

The smallish boat had been transformed into an offshore fishing machine over the course of three hours the prior afternoon. She was loaded with four Penn International 30 wides and a pair of 50s. Onboard were a couple gaffs, the insulated fish bag and a small cooler laden with brined baits affixed to Sea Witches in a rainbow of colors. Six larger, or horse, ballyhoos were fed onto larger lures, and three were rigged naked. They would be deployed on the larger 50 Internationals in the event that a larger pelagic predator would make an appearance in our spread. Though we would certainly be

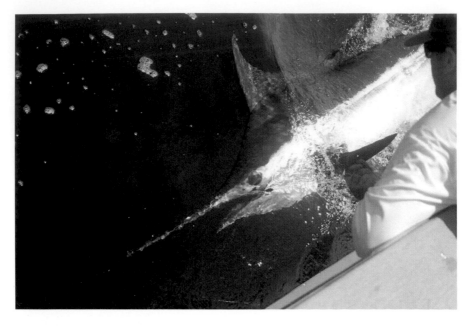

Seemingly under control, this angry blue marlin is focused on the hook stuck in his jaw. *DaBait photo*.

the smallest boat in the fleet, we wouldn't be undergunned. We also didn't suffer from a lack of confidence.

On the ride to the little city by the sea, there was a noticable calm in the air. We spoke very little, each sipping on rather tasty coffee from the Shore Stop. The boat was launched with little issue and was idling nicely as I returned from parking the truck. I hopped aboard and we began the seven-mile trek toward the Wachapreague Inlet. We fell in behind Captain Nat Adkinson on the *Foxy Lady*. Nat's boat wasn't the fastest in the fleet, and he used that to his advantage. Often he left earlier than his counterparts, and his lack of speed only enchanced his skill in fishing the inshore waters. He knew where every bump, hill, engine block, snag and upwelling was located that might hold a fish. He could catch them as well.

We made thirteen knots following him through the inlet and past the "C" bouy. Bill bumped her up to twenty-three knots on the flat surface of the ocean. Our ETA to the northern end of 26 Mile Hill would put us there right at sunrise. The ride there was uneventful. As we slowed to trolling speed two miles short of our waypoint, the outriggers were deployed and baits began to hit the water. The flat lines were first to go over. Clipping the second line to the transom clip, we took a second to admire how nicely they

were swimming. Long riggers were sent out next to a distance of about one hundred yards behind the boat. Short riggers, with the larger baits on the 50s, split the distance between the flats and longs. We worked independently and in unison. If there was going to be an early-morning bite, we were going to be in on it.

Bill took the helm, and I took to the tower to survey the spread. Well, actually, it wasn't a tower. In actuality, I stood atop the cooler seat in front of the center console. From that vantage point I saw the first flash of neon green pick off the starboard long bait. The gaffer dolphin jumped almost immediately as line began to peel off the reel, the drag of the Penn making that special sound that all fishermen treasure. As I brought the fish boatside, Bill leadered and gaffed the fish, cleanly swinging it into the open 128-quart cooler in one continous motion. The skunk was out of the boat. We bobbed and weaved through the increasing number of boats for the next hour before we had our next customer.

This bite was unseen. There would be no jumping and no flashing in the baits, just an old-school street fight. It was down and dirty. There was little doubt that this was a tuna. I took the wheel as Bill settled into the circular battle that marked the near end of the fight, or so we thought. This fish had heart. After nearly thirty minutes, I sunk the steel through his head. Our first bluefin of the season joined the dolphin in the cooler.

While we'd had a rather busy morning thus far, we couldn't help but overhear the chatter from the boats off on the thirty-fathom line. A few billfish had been sighted, and stories of dolphins and tunas being boated were coming across channel 69 with increasing regularity. We both were thinking about it, but neither voiced it until we got that call from Captain Mike Parker on *The Lucky Dawg*. Parker commented to Bill, "If there was ever a day to catch a billfish on a small boat, today is the day." With a small bit of coercion, we pulled the lines in and headed offshore. We pulled the throttles back at the thirty-fathom line and pointed her bow to the north toward the bumps just inside the Washington.

There was a definite color difference between the 26 Mile Hill and our current location. No longer was it the off color green, but rather a deep, clean blue. The water temperature difference was six degrees. Large sportfishermen from Virginia Beach and Ocean City trolled in the same area. The Lord only knows what they thought when they saw us out there in the deep. Quickly, we got our lines in the water. After a little adjustment, we were right where we wanted to be. We began to wonder about the sanity of our decision after the first hour of trolling left our baits undisturbed.

The second hour passed with just one more small peanut dolphin to show for our efforts.

Still pushing northward, I made for the outside edge of the bump. Bill went forward to pull a pair of cold Buds and our subs out of the cooler. Driving along with my back to the west, we nibbled on our food and savored the cold beer. In the calm water, the wake pushing ahead of the fish was very obvious. In disbelief I saw this massive blue-and-gold missle building speed toward the port shortrigger. I couldn't speak in full sentences. Never had I seen such an animal move with such speed and precision. The words that came out were, "Bill…Bill…Billfish!!!!"

The fish hit with aggression, the rod doubled and line sped off the reel with a pace that I had not experienced. Bill pulled the rod from the rod holder, and I supplied him with a fighting belt. Quickly, I started to clear the lines, but that plan had to be aborted as the fish greyhounded away from the boat in a wide clockwise arc. Luckily, we had him on the 50. Bill just held on as the line peeled off the reel. My first instinct was to chase the fish, but I chose wisely and began to chase the line. Half a spool was gone and it was departing quickly. Bill moved to the front of the boat as we attempted to get line back on the reel.

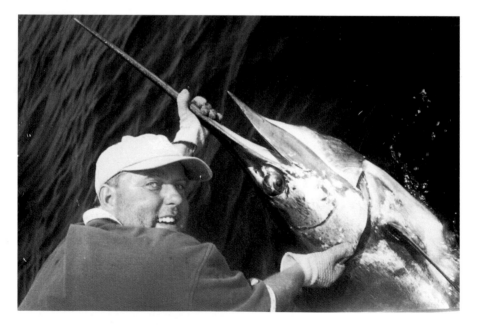

Bill Hall fought and landed this blue marlin aboard his nineteen-foot *Fishmaker*. I was lucky to be at the helm. *Bill Hall photo.*

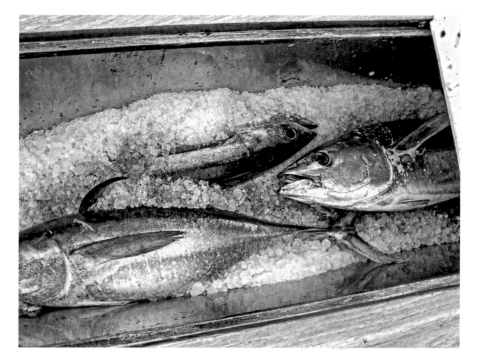

A box of iced tunas can be the reward for a good day offshore. *Paul Bramble photography*.

The radio was ablaze with chatter about the "little boat." The entire fishing community sent suggestions and well wishes in our endeavor. At the forty-five-minute mark, we'd gained much of our line back, only to have it stripped off again. This ordeal replayed over and over again. I sent out a request for harness for Bill. The belt had broken, and he was nearing the hour mark in this battle. Without a harness we had little hope of successfully landing this fish. Nick Katrobus, on his Maine-style boat *Tuna Fortuna*, didn't hear the call, but he did inquire about the "little boat" dead in the water and called to render assistance. I quickly answered on the radio as the fish made another long run to the starboard, launching its heft airborne in full view of the Katrobus crew. Nick quickly backed to our port side, tossed us his harness, asked if we needed anything else, then eased off to watch the show. Momentarily leaving the helm, I retrieved the harness and quickly strapped it to Bill and the rod. He took a little break and then began to work on the fish.

Just after the two-hour mark, the fish rose to the surface and seemed to just linger there. Only twenty yards away, I needed to cover half that distance

to get our hands on the leader. Touching the leader signaled a release, but I wanted to get our hands on this beast. In the gentle rolling swells of the ocean, I thrust the engine in reverse and quickly cut our distance in half, as Bill performed admirably on the reel.

With the boat at idle, I pulled the fish toward me and grabbed the bill. The old girl was played out. So was Bill. After a few quick pictures, forward gear was engaged and we "swam" the thirteen-foot fish beside the boat until she signaled her time to go with an angry thrash of her great bill. With that she slowly departed our company and returned to the deep. Crossing paths undoubtedly left an intense memory with all involved.

5

CHRISTMAS RED TREATS

Wading out on a small sandbar in the Gargathy Inlet with a light spinning rod in my hand, I fired an orange jig head adorned with a "chicken on a chain" soft plastic lure seaward. Feeling the lure hit the bottom, I firmed up my footing and gave the lure a twitch. As the lure fell back toward the sandy bottom, I felt a strong thump on the end of the line. This sensation was followed by a strong run aided by the outgoing tide. The first cast of the afternoon produced the anticipated result. Line left the spool of the Penn spinning reel at an alarming pace. I leaned back against the seven-foot Star rod trying to slow the spot-tailed beast. As the fish made a turn back toward the beach, water lapped over the top of my hip boots. It really didn't matter. We were on the reds.

It was a fishing season like no other we had experienced on the Eastern Shore of Virginia. We annually have opportunities to catch the largest of many inshore species, such as black and red drum, cobia and striped bass, but the latter part of 2014 provided us a fishery that we certainly didn't expect. The 2013 season brought us annoying numbers of first-year redfish. Countless numbers of six- to ten-inch reds had invaded every inch of the Tangier and Pocomoke Sounds. Bait fishing the shallows for speckled trout and bull reds got almost intolerable as the hordes of small reds devoured any morsel of bait that found its way to the grassy bottom. Our skill using artificial lures grew.

Though they did not reappear in the bay with such numbers in 2014, they made a strong June appearance at all places along the seaside of Virginia's

Eastern Shore. From Kiptopeake to Lewes, anglers were treated to fishing equaled only in areas historically famous for it in the Mississippi Delta. We first started catching them with cut mullet with top and bottom rigs in channels bordering shallow water oyster bays. From there, we graduated to pitching meat-tipped bucktails to them in the mouths of guts on ebb tide. As we continued to focus solely on this fishery, we learned with each trip. It was a very new activity for us in the upper mid-Atlantic. Borrowing heavily from our fishing bretheren to the south, we became increasingly proficient at finding and catching these redfish invading our waters.

Mid-October found Keith Aydelotte and I searching for them in the Queen Sound area. Well, searching wasn't a good word for it. We knew where they'd most likely be. On a flood tide we positioned our skiff just south of the Queen Sound Bridge on the east side of the channel. Making our way through the oyster beds that border the deeper water, we found a good number of reds on the inside of the bar. Our limit of three apiece was quickly attained using any combination of white artificial lures. We decided to look for options closer to the Greenbackville boat ramp for our next trip.

We ran quickly back to the north side of the Queen Sound Bridge and began to search the flats area about a mile north of the bridge. Nothing jumped out at us, so we eased toward Red Hills. Passing the mouth of Mosquito Creek, we slowly cruised the edge of the shallow water looking for feeding fish. Stopping to activate our internal bilge pumps, we drifted along with the motor in neutral. We continued our drift to a piece of water that looked interesting. Suddenly, the lower unit struck something hard, and the boat lurched to a quick stop. It sent Keith to his familiar seat atop the Silver Bullet–filled Yeti. The water came alive with the sudden intrusion of noise. Fish were everywhere. For the next hour, we fought fish continually in water not more than eighteen inches deep. Finally, a bull red pulled us off our position, and we began to drift northward along with the incoming tide. We continued to cast back toward the little oyster bar, catching fish until we finally drifted out of casting range. With that, Keith pulled a pair of ice-cold brews from the Yeti, and we slowly made our way back to Greenbackville as the sun sank below the tree line in the west.

Our good fortune continued throughout October and into November. As Thanksgiving approached, we turned our attentions to ducks and rockfish on the bayside. These activities occupied our time for the better part of December. With Christmas fast approaching, we thought we'd give the reds a try just one more time. We all agreed that they should be schooled up near the mussel beds just north of Gargathy Inlet. Three days before

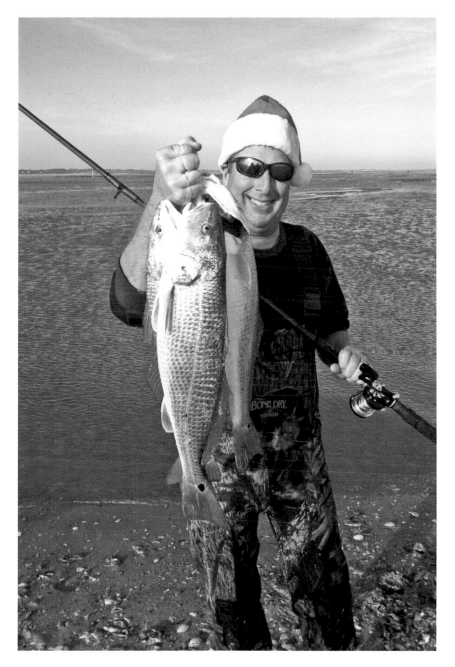

Bill Hall hoists a limit of Christmas Eve red drum. In perfect conditions, three of us caught more than one hundred in the two days preceding Christmas in 2014. *C.L. Marshall photo*.

Christmas, accompanied by the usual suspects, we headed to the barrier islands with surf rods in hand.

The action proved to be hot and heavy. Our twelve fish were landed with astonishing proficiency, although not providing much of a sporting fight, as they were overmatched by our heavy gear. As soon as the cut bait hit the bottom, the feeding frenzy began as the reds raced to the bait. Leaving laden with fat redfish, we agreed to return the following day with lighter gear. The next day, four of us ventured out in the rain of late December armed with boat rods. We thought that lighter gear would give these eighteen- to twenty-four-inch brutes more of a chance in the two-foot surf. Once again, the outcome was predictable. Fishing was as good as it could possibly be.

On the way home, I placed a call to CCA executive director Dave Sikorski to tell him of our good fortune. He'd been down a couple times during the duck season to help me handle a teal infestation that I'd been dealing with; he had preformed admirably most of the time. Quite shocked was he to hear what we'd been experiencing. He wanted to get in on it. In Ellicott City at the time, he assured me that he'd be in my driveway in three hours. That promise was kept. The following morning, he, Bill Hall, Parker and myself headed out to the same area just after sunrise. Pulling the boat up on the beach, the anchor held it tight to the bank on the rising tide. Our gear was quickly unloaded, and we began the one-hundred-yard trek across the barrier island to the point where the fishes had been schooled for the last three days. During that time, we'd caught at least one hundred. We fully expected a repeat performance. It began immediately upon our return.

Parker and I had absolutely crushed them the past two days. Sikorski was new to the game. Bill had been with us twice before. There was no need to explain how this game would be played to these two. Surveying the situation very quickly, Bill and Sikorski were baited, and fish-finder rigs launched toward the area where the fish should be holding. The question of their presence was immediately answered, as Bill and Sikorski both set the hook aggressively on keeper reds. Parker and I opted to try to catch them on artificial lures as we'd been doing in the bays and guts along the interior of the barrier islands. We felt as though it should work in the surf. After a little fine tuning, we found a pattern that produced fish after fish. At least one of our foursome was tied to a fish at all times. Over the next three hours, we wrestled and released more than one hundred fish among us. The bite was literally wide open. In efforts to maximize catch in minimal

time, casts were limited to less than twenty yards. It didn't matter. There was no telling how many fish were on the outside of the bar on that day, but they were there in huge numbers and feeding greedily.

The four of us, donning Santa hats in colors from bright red to dark brown old-school camo, spent the better part of a Christmas Eve morning enjoying life on the Eastern Shore to the fullest. Alone on a barrier island, we were living by the tide and enjoying the bounty that Mother Nature was providing us. We took full advantage of the opportunity.

6

FULL CIRCLE

With a plume of gray-blue smoke, the old two-stroke Yamaha 90 roared to life one more time. Its skeg had been broken off years ago, along with a piece of its lower unit housing. It was old but had yet to let me down. Today was no day for it to start misbehaving. Seated on the middle seat wrapped in too many clothes was my oldest son. It was the first trip of his hunting career.

The night leading up to his opening day, we worked feverishly to get the boat loaded. It was understood that if he or his brother were to take part in the gunning, then they would have to aid in the prep of the gear. He gladly did so, feeling very confident about his role in the coming day. He proudly slid his Red Ryder lever action into his case and set it beside my old pump gun. He made sure that he had an extra one-hundred-pack of BBs in our gunning bag.

For his first hunt, I planned to keep it rather simple. We would enjoy a short hunt, followed by some progging for driftwood along Sandbar. The tide was on the rise as the engine slid into forward gear. In the bright moonlight of the predawn, I could gauge that there would be plenty of tide for me to get through Back Creek. After making his zipper tight under his chin, I called on the old engine to push the flat-bottomed scow up on plane. As per usual, it responded when called upon. A wide arc to the east ensured that we'd miss the newly formed sandbar and remnants of work boats that had long ago seen their prime. I could see the joy in his face as we zipped through the tight turns in the shallow creek. He had made this ride before in much warmer weather. This time, it was for another purpose.

As we cleared Back Creek and entered the larger waters of Broad Creek, we slowed a bit to make transit more comfortable. The northeast wind had placed a small chop at our stern that steadily increased as we progressed to the southwest. Near its mouth we hung a hard left and simutaneously backed off the throttle. Nosing into the mouth of a small tidal creek, we started to idle toward a spot a couple hundred yards back in this marsh. Arriving in front of our low-profile reed-thatched blind, I hit reverse, stopping the skiff dead in the water. He and I gingerly placed six hand-carved black duck decoys, in pairs, in a thirty-yard span alongside a small sandy island. Killing the engine, I poled to our blind. The eager six-year-old hopped over the side with bowline in tow. His job was to hold the boat tight to the bank. He took it seriously. After unloading the guns, blind bag and other necessary gear, I took the bowline from him and instructed him to wait in the blind until I returned from hiding the boat. He was not to uncase the guns. We still had thirty minutes before legal shooting time.

The boat was quickly stashed in a phragmites-lined gut about one hundred yards from the blind. As I walked the very familiar path back

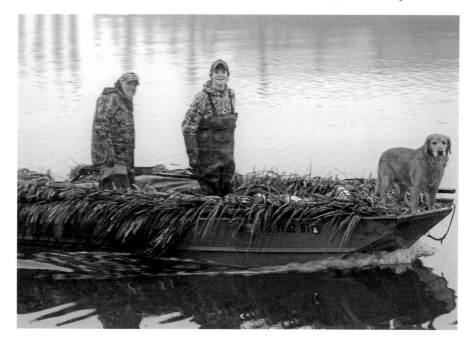

A good day of gunning is signaled by the smile on Parker Marshall's face as we ease back into the dock at Starlings Creek. This was Gunner's last trip. *Jim Lewis photo.*

to the blind, I could see his flashlight searching in the blind bag for the necessary calls and such for the morning's hunt. About halfway there, he let out his first highball ball of the day. I'd save that conversation for later in the hunt. Prior to taking my seat beside him, I removed his outer layer of clothing. Pouring us a cup of hot chocolate, I was bombarded with questions. Why had I placed the decoys like that? How much longer before we can shoot? When was the last time you hunted up here? What did you kill? Do you think we'll get to shoot today? Are we gonna get stuck up here? All of these and a thousand more were patiently answered. Our Q&A ended as a chatty black duck, then a pair of green-winged teal, splashed down in the decoys. With just over ten minutes to go before legal shooting, and our guns still cased, we just watched them get comfortable then begin feeding. Trying to ease our guns out of the cases, the three made a clean escape. Locked and loaded, we waited anxiously.

Legal shooting came and went with little fanfare. His young eyes saw everything. Quickly, he grasped the differing wing beats and sizing of flying fowl. We practiced rising to shoot, with him lobbing BBs at the farthest decoy with his trusty Red Ryder. Just prior to the sun greeting our horizon, a single black duck rose from a distant pond, flying just above the tallest reeds toward our decoys. At about forty yards, he set his wings and began his descent straight into our decoys. I prayed that I wouldn't miss this shot. I rose to shoot, but my first shot failed to find its mark. The second time, the pump gun barked and stopped his flight and sent him tumbling backward into the shallow water. The pressure was off as Gunner delivered the fat black duck to hand then took up his traditional spot twenty yards right of the blind.

With the duck in hand, I took the time to show my son how the lack of markings on his pale-yellow bill identified him as a male. We talked about who had hunted up here in this shallow slough before us and about how my father had shown me this spot back when he was hunting. He and I had spent many good hours on this tiny sliver of water. Age had now slowed his ability to get back to such far reaches of the marshes but had not tamed his desire. These ducks had been a bonus.

The pressure was off. Our day was a success. After another round of questions and some more shooting practice, we began to talk about the next segment in our adventure. He pointed out four large ducks headed north between us and a large hammock of pines two hundred yards in the distance. Together, we called hard with the occasional offkey note. Nonetheless, these four slowly turned, circled a few times and fell into the

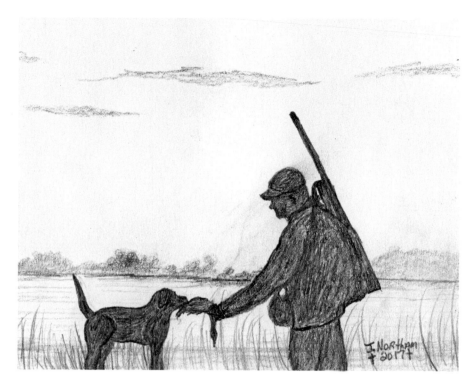

Joyce Northam drawing.

decoys. I called the shot, and the boy got off two with his Red Ryder. My first shot sent a hen mallard cartwheeling into the decoys. As I pulled on the second—a fleeing drake green head—the morning sun glistened off his flouresent feathered head. Pausing a millisecond oddly, to etch that memory in my mind—before pulling the trigger, I hoped that my aim was true. The bird's escape was thwarted by a full pattern of #2 Federals. There was no third shot. I was amazed that I'd pulled off a double.

Placing my gun back down to its resting place, I looked over to my son. He was busy lobbing BBs toward the hen mallard to make sure she didn't get away. Gunner returned with the drake, then set his sights on the hen who had drifted almost directly in front of the blind. Sitting back down inside the blind, I explained how lucky we were to have killed a double. His response was not what was expected from such a young hunter.

"You must have had some help from Pa," he said quite matter of factly. I asked him why he said that. Again, another response far beyond his years: "Well, I've seen you shoot clay pigeons and sometimes you're not so good,"

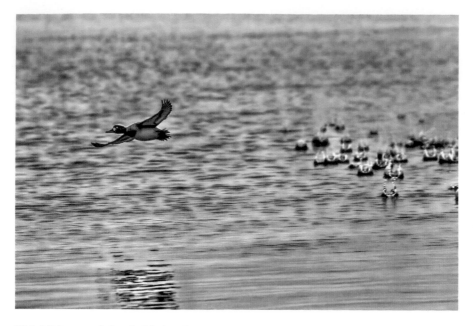

This bird escaped cleanly. My hunting partner took some good-natured ribbing for his lackluster shooting. *Paul Bramble photography.*

he said, choosing his words carefully. He added, "It felt like Pa was right here with us, helping us aim at that second one."

Late that night while making the day's entry into our hunting journal, I made certain to make note of that. He may have been right.

7

FRIENDS IN LOW PLACES

Opening day of the October split of duck season had come and gone in the Free State. The spring and summer had been favorable for breeding local wood ducks. The fifty or so wood-duck boxes erected over the late-winter months by a host of volunteers had done their job. Early scouting in late summer provided evidence of the breeding success that these boxes had had on the local wood duck population. Our first two hunts of the year had confirmed it.

Opening day on a public marsh is quite an ordeal. All duck hunters should experience it at least two times. After the first time, most will walk away wondering just what the hell happened. A second experience will allow the unindoctrinated to soak up more of the chaos that surrounds it. It's a first come, first served type of environment. For many, like myself, it's a first real chance to get duck hunting. It brings out all the kindred spirits. Yes, once muzzleloader season for deer starts, the once-bustling little ramp only handles a few boats a day. That number usually falls to just one or two as the season winds down. Now, on a midweek day toward the middle of the second split, the ramp served just two.

Launching my boat early on a moonless morning on a strong outgoing tide, I thought it strange that I was the only person at the ramp. My young chocolate Lab, "Milo," and I hopped in the boat, fired it up and quietly made our way to a bush blind deep in the cypress swamp. Making our way up a narrow gut against the strong outgoing tide, I understood that this morning's hunt would last only ninety minutes or so if I planned to make

it to work before 9:00 a.m. On the way in, I haphazardly tossed over half a dozen wood-duck decoys and continued to the creek. The boat was stashed in a small feeder gut, bowline lashed to a two-by-two pole planted there for that purpose. The old Remington, fifteen or so shells and my ever-present five-gallon bucket were snatched up out of the boat, and Milo and I made our way to the vegetation-covered blind.

This was Milo's first true year of hunting. I'd picked her up from Dave Bramble in Tolchester as a pup, and in her first few outings of the last season, she'd shown promise. Her skill thus far in the season had exceeded my training ability. She was eager, hyper as hell and blessed with a keen nose. In her first few hunts, she'd performed admirably. The little chocolate Lab proved to be a bit hard to control at the blind, but she marked and found birds very well. She knew what her role was. These wood ducks were primarily passing shots. Birds that were hit fell in thick vegetation, in muddy muskrat leads and in other areas not accessible by man. She found them routinely.

Things got underway quickly, most likely a couple of minutes prior to legal. A single wood duck hovered near the mojo, resulting in an easy retrieve. I shot selectively, taking only shots that I felt had a high likelihood of success. In twenty minutes and with only five shots, my three woodies lay lined up in the bushy hide. Five more minutes were allotted in the hopes that a few bluewings would pass by. The time passed with only more wood ducks being interested in our location. As the sun began to shine through the line of cypress trees to the east, we began our short trek back to the boat. About halfway there, five shots rang out only a couple hundred yards from my location. I was glad to be heading out with only a limit of three woodies. I was unsure of who had come up the little creek behind me. It was an uneasy feeling. My thoughts raced as to just who these folks were. Thinking back to other "confrontations" that I'd had in this same marsh, I could feel my blood pressure beginning to rise. Public hunting is not an endeavor for the thin-skinned. Reaching the boat, I was looking forward to chatting with these so-called hunters who had the nerve to hunt on "my" public marsh. Hopefully, stern talk and hot air would prevent them from a return trip. I wouldn't mind if they called me an ass, jerk or whatever they chose to, as long as they left my wood-duck hole alone.

Milo hopped in the boat eagerly, as if ready for the next adventure. I, on the other hand, ambled along the edge of the creek gingerly. This marsh is one of the harshest to walk in that I've ever seen. A spill in the muddy creek wasn't in my plans. Unleashing the bowline, I dropped the

gun and birds in the boat. A couple shoves on the push pole and the boat entered the fast-ebbing creek. There wasn't enough water to operate the motor. Mud, seemingly fifteen-miles-deep, and silt made poling somewhat difficult. I used small, short, shallow strokes, keeping the aluminum hull away from the "three sisters" stumps exposed on the starboard side of the creek. Drifting with the outgoing tide to the front of the blind, I quickly picked up the six wood-duck decoys. Finding deeper water in the larger entrance creek, the motor was engaged in shallow-water drive. The two hundred yards were traversed with some difficulty. I was glad we were getting out of there when we did.

Rounding the last bend, I slowed due to the decoy spread at the entrance to my little creek. The spread was appropriate for the type of hunting. Across the creek, two hunters sat in their boat. I eased over to see how their morning was going. It was the least I could do after driving through their spread. We chatted for a few minutes about my fortune this morning. They confided that they had knocked down a pair earlier, but after half an hour of searching could not locate the two birds in the dense marsh. Since the morning flight was clearly over, and the clearing skies proved that the day would be more suited for rockfishing than duck hunting, I asked if it'd be all right if I tried to send the dog to find them. They agreed. Neither they nor I expected much to come out of this exercise.

I nosed the boat on the soft mud on the opposite shore, then Milo exited quickly. She stood broadside, awaiting me to come ashore with her. I had no plans of it. As she heard me order her into the marsh with the usual four-word command, "Milo, get that sumbitch!," she sloshed off through the water and mud. Moving through the vegetation, I quickly lost sight of her as she searched in various muskrat leads and crevices that made up the pockmarked terrain. Emerging from a muddy slophole with the hen wood duck firmly in her grasp, she bounded back toward the boat. Delivering it to hand, she was re-deployed in attempt the find the second bird. She returned rather quickly with the second. I must say that I was quite the proud dog owner as we returned across the creek to deliver the fowl to the waiting hunters.

Upon delivery to the two young hunters, they were very complimentary of the dog's effort. I was utterly shocked, thinking that we had little chance of finding one, much less both of the felled woodies. I pulled alongside their boat, and we sat together and took time to have a cup of coffee while Milo jumped ashore looking for whatever was next for her. I certainly didn't mind her swimming to get the mud off her prior to jumping into the truck.

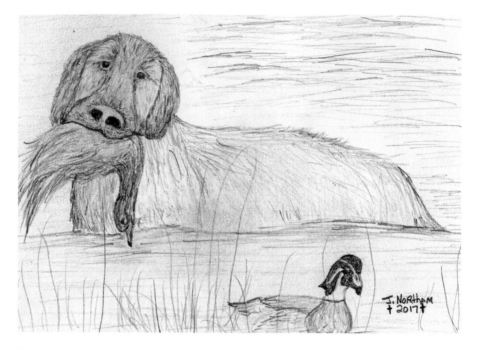

Joyce Northam drawing.

Introductions were made. Prior to us parting ways, one of the young men, Elliott, pulled his duck call off his lanyard and handed it to me. I resisted, but he was insistent. Upon inspection, he informed me that he had in fact made it himself. I hit it a few times; the sound was just what I was looking to add to my arsenal. I appreciatively accepted it and made my way back to the ramp.

That call still occupies a loop on my lanyard to this day. Each time I call on it to perform, it does. Several times, it has provided me with just the right sounds to convince the birds to fully commit. Each time I use it, I can't help but think of the young man who made it. Most important, I recall my personal lesson learned. I remember that there are still some good souls who take to the marshes for all the right reasons.

All hope is not lost.

8

GIMME BOBBY'S GUN

The gunning season was drawing to a close, and in our circles, one of two things were occupying our time. If we weren't hunting, we were planning to hunt. If the late-season weather was frigid and ice clogged the bay, we were chasing canvasbacks, redheads and broadbills on the high tide. Low tide brought smaller water, airholes, puddlers and geese. Work was put on the back burner. We were living by the tide, not the time.

We'd been working on the divers on a fairly consistent basis. We'd routinely place bets on how quickly, and with how few decoys, we could limit out. Three of us limited out on canvasbacks and scaup, with a few bonus teal with nine decoys in just over twenty-eight minutes. It was as good as it could possibly get. The hunting was so good it brought out the folks who had long ago put their guns up due to lack of birds and excessive regulation. The thought, the promise, of seeing flocks of divers brought them out again. They could see the excitement in our eyes as we told tales in the local bars of the day's hunts. They heard others who had ventured out back up and add details to the daily accounts. We were relishing the fact that so many "retired" hunters were calling, wanting to get back into the action.

It had been a few years since my hunting partner Bobby Graves had ventured to the open waters of the Chesapeake Bay looking for big divers. His time had been spent chasing deer and geese in the upland area. My recount of the incredible shooting we were experiencing rekindled that fire deep within him. He and his youngest son, Jake, agreed to join me on that afternoon's hunt. Our plan was to leave at 1:00 p.m.

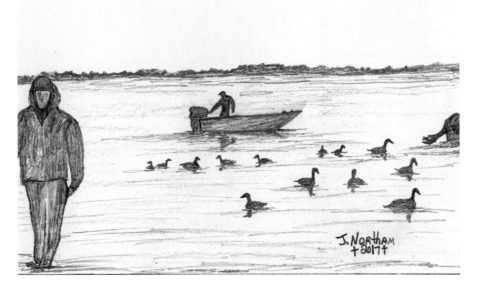

Joyce Northam drawing.

I loaded a couple dozen Herter's Model 72 cans in the aluminum johnboat. I figured that would be enough divers to get the job done. I also knew that it wouldn't take long for us to find our limit of cans, plus a few extras. We'd planned to hunt the entire afternoon, so I thought we'd make the most of it. I threw in a couple dozen floater goose decoys for good measure. The recent cold snap had pushed a few geese down to the Pocomoke area, and they sought water most afternoons around dark. I had a good idea where to find them.

The *Drum Boat* was launched at Pitts Creek; within a half hour, we were tossing decoys haphazardly into the dark waters of the Pocomoke Sound. A gentle northeast breeze wafted from right to left, and this brought the foam-filled canvasback decoys to life. They bobbed and darted in irregular directions, seeming as lifelike as foam decoys could be. The geese were stowed in plastic totes that were moved out of the boat and hidden along the reedy shoreline. This provided ample room for the three of us to tend to the matter at hand.

The blind was erected and guns were loaded. As I reached for the old Stanley thermos for a cup of coffee, our first customer slid in unannounced.

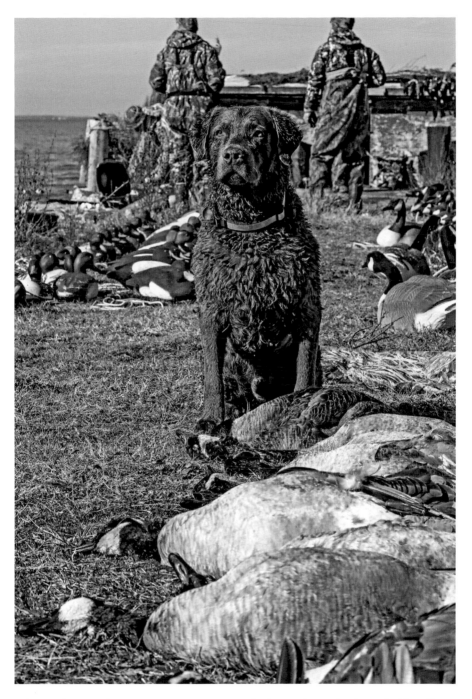

A hearty Chesapeake poses proudly with the result of a good morning hunt. *Paul Bramble photography*.

After some coaxing, the bull-headed beast found flight, then caught the full force of Jake's #2s, which thwarted his escape. As we watched him drift facedown through the decoys, a flock of five rounded Pig's Point and made a beeline for our location. Flying low on the water, their low direct flight revealed that they were on a mission. At a distance of three hundred yards from the decoys, in unison, the five quickly gained ten yards of altitude. I laid back and watched. Graves knew what was to come next. He'd seen this before. It brought back many memories, but there was no time for reflection. With the newly gained altitude, the five swung a little downwind, set their wings and began their final descent into the decoys. There would be no circling. As their big gray feet stretched to greet the water, their wings cupped to slow their approach. I called the shot and watched, coffee in hand, as the father-and-son team pulled three out of the flock. We took turns on singles for the next forty minutes until we reached our limit.

We sat, sipping coffee and nibbling on porkchop sandwiches, watching several other flocks work the decoys. Bobby went to fetch the totes containing the decoys from the bulrushes while Jake and I pulled the diver blocks into the boat. We pulled the goose decoys out of the totes, placing the divers back in their usual home. With both sets of decoys loaded in the

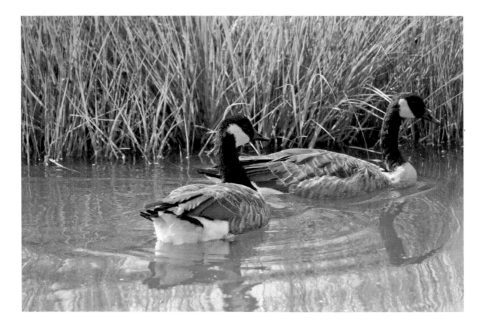

The resident population of Canada geese has recently exploded in the Chesapeake Bay region. This is a boon for hunters and an issue for property owners. *Jim Lewis photo.*

boat, we deadheaded the small swell until we found the Pocomoke River, then accelerated up the river. We stopped by the Pitts Creek launch ramp and unloaded two tubs of diver decoys plus our kill into the back of my old Tahoe. Repositioning the two dozen goose decoys in the small boat gave us ample room; as with any small boat, proper weight distribution is key to a good ride.

We were quickly back on plane and en route to a location somewhere between Miona and Pitts Creek. Over the past week, there had been a huge increase in goose numbers, particulary in the pond and surrounding fields of the uninhabited Black Water development. We felt with certainty that we'd have an opportunity to add some fat honkers to our bag, rounding out a stellar day on the bay. We settled on an area where wide marshes adorned either side of Pitts Creek. Such width would allow incoming geese ample room to work into our spread. Plus, we felt it looked inviting. Small patches of reeds would provide a backdrop for our boat blind. This was critical to break up our outline. We dropped the decoys and set up shop.

The action was not as fast and furious as our diver shoot earlier in the afternoon. In fact, it was slow. The wind had fell out, the sun had appeared and it was downright balmy. We thought, correctly, that the geese would fly on this afternoon all at once —and late. We settled in for the duration. Watching the sun fall past the tree line to the west, we could instantly feel the added chill. We could hear the geese feeding greedily in the field just on the Maryland side of the creek. They weren't far away, we just needed them to get moving. We felt that we'd have a shot.

Just as the sun was about to set, they began to get out of the field and search for a drink before settling in for the night. We called to flock after flock, with no interest. It became evident rather quickly that our location wasn't on their agenda. Knowing that it most likely wasn't going to happen for us, we decided to pack it in. Jake and I slid our guns into our cases. Bobby laid his, uncased, atop the two cased guns as the blind was lowered and decoy retrieval began.

I slowly motored uptide and dropped the engine in neutral. We began our drift through the line of decoys. We each grabbed a goose and began the laborious chore of keel-wrapping the large plastic floaters. As I passed mine forward for proper storage, four geese crested the tree line and did the unexpected. Rather than follow the flight path of those before them, they locked their wings and fell directly into our decoys. Though we floated, uncovered and standing erect in the boat, these geese just wouldn't take "no" for an answer. Splashing down just thirty yards from us, they could sense

something wasn't right, but they'd made their decision and now would have to live or die by it. As the boat swung around, my position in the stern of the boat would be afforded a quick opportunity to add to our bag.

As the the other two in the skiff watched the nervous geese slowly swim away honking loudly, I reached in the pocket of my camo bibs and produced two shells. Nudging Jake on the elbow, I said, "Gimme Bobby's gun." He calmly did as requested. The old Remington was loaded quickly, and with no time to spare. As the receiver slammed shut, signifying that a shell was now chambered, they began to take flight. A first shot left a gander on the water. I don't know who was more surprised, the gander or Bobby, who had continued decoy retrieval. If he didn't think that I was gonna shoot, then they both were sadly mistaken. The second shot found its mark as well. Two lay belly-up, fat feet paddling at the air, drifting peacefully out with the swift-running tide.

It was the end to another good day on the bay.

IN THE LEE

It was a bittersweet day as I watched the twenty-foot Gaskill scow hitched up to another man's truck and rolling down Virginia Route 695 en route to her new home. Dubbed the "Saxis Island Sportsfisherman" by some of my fishing friends, it had traversed waters on the bayside and seaside of Delmava for nearly a decade. It was legendary.

It had hauled cobia, red drum and black drum ashore from Kiptopeake. It made countless trips to the Tangier Target Ships, successfully finding tiderunner trout, spadefish and rockfish. It was also a frequent visitor to the vast grassy flats off Smith, Bloodsworth and South Marsh Islands, encountering speckled trout and puppy drum. Flounder from the nearshore wrecks and shallow-water bays near the barrier islands found their way home in the boat. My son had used it on his daily commute to Shad Landing during his high school and college days working as a lifeguard. On many afternoons, it doubled as a wakeboard boat.

The plan was to get into something else fairly quickly. Finding something in our price range was proving to be more of a challenge than I'd expected. Time wore on, and my need for a boat was tempered by occasional fishing trips with friends, but they were getting fewer and further between. It's odd how quickly the phone stops ringing when fishing season comes around. I'd managed to get through the first few months of the year without a boat. As June came around, tales of the occasional fish caught off Sandbar Point began to be more frequent. It became more than I could bear. My gunning skiff would be put into service.

The sixteen-foot riveted aluminum johnboat powered by a twenty-five horsepower Yamaha had provided me with several years of good gunning. With a "custom" scissor-style pop-up blind bolted to its gunnels, this flimsy platform has many times been the ride of choice when the wind prevented the local oyster boats from going out. It is a little crazy how we'll eagerly hop aboard it on days when the fleet of thirty- to forty-foot deadrise boats were lashed to the piles in the harbor. We did it with regularity.

With the blind taken off, I'd removed the flooring and relieved its false bottom of no less than twenty pounds of crap that it had collected over the gunning season. Somewhat cleaned up, it was my only reliable mode of transportation to the fishing grounds. The first few trips to the shallow bays around Gargathy had produced a few flatfish, but nothing noteworthy. It had preformed as expected.

Friday's forcast was for light winds from the northwest and temperatures soaring toward the low seventies. The water temperature was nearing sixty, and things were beginning to happen. The full moon neared, and from all indications, the double crab run would be a good one. Black-headed gulls roamed the shorelines picking up small he peelers and soft crabs that seemed to be shedding everywhere. Undoubtedly, there'd be some fish easing up in the shallows on flood tide to join the feast. The tide was to turn to ebb about ninety minutes before nightfall. The stage was set. The only uncertainty was whether the players would cooperate. I planned to do my part.

I'd planned to venture out solo, but during a Thursday chat with Bobby Graves, he indicated that his incoming flock of chickens had been pushed back a couple of days. He graciously accepted the invitation and seemed eager to experience something new. I was glad to have his company. Our plan was to fish the last hour or so of the flood and the first hour or so of the ebb. Since the gunning skiff had no navigational lights, we planned to be back at the dock before dark. I had a plan in mind.

He hadn't thought much about fishing in this little boat until he pulled into the driveway and began to unload his gear. A cooler, a pair of rods apiece and a net took up nearly all the empty space in the little boat. With him on the middle seat and myself at the tiller, we'd have a full load, but we'd be fishing, and that was just fine with us. With our gear secured, we began our journey southward a little earlier than expected. Like most trips out of Saxis, it consisted of stopping by Arnold Ray Evans's crab shanty on the way out for peelers, a couple shovels of ice and the obligatory Natural Light.

Stepping back aboard the boat, I noticed that the wind wasn't the light and variable kind that had been forcasted. Instead, the ten- to fifteen-mile-

Sunset on the Chesapeake, like this one seen from Creek Point in Saxis, Virginia, is a treasure for all who live near the Chesapeake. *Jim Lewis photo.*

per-hour breeze pushed two-foot swells from Apes Hole toward Saxis across the Pocomoke Sound. As the tide was up, it was an easy decision to run through Back Creek, hang a right into Fishing Creek and fairwind the last half of a mile to Sandbar point. My plan was to anchor behind a small protruding tump of marsh about 125 yards off the beach. It seemed like a good place to fish.

Breaking out of Fishing Creek into the Pocomoke Sound, we had only a short broadside run before settling into the downsea part of the ride. Knowing how poorly this boat runs in these sea conditions, I eased off the throttle and slowly made our approach to the area we intended to fish. Bobby asked if I'd planned to go around the point into the calmer water. He looked puzzled when I told him that my plan was to position the boat on the downwind side of the smallish tump of marsh grass sticking out of the bay. "I'll put her in the lee of that island," I told him. Glancing at the tump, submerged by the flood tide, it was clear to him that the few stems of marsh grass breaking the water's surface would offer little protection. I was sticking with my plan.

As I nosed the boat up to the sparse collection of spartina, Bobby glanced back wondering when to toss the anchor. His heave was true, and the grapelin caught the far side of the tump. We were snug. As the tide fell, I was confident that we'd be afforded increased protection as the tump became more exposed. A stern anchor was deployed to keep us from cutting and sheering. It made fishing much easier.

We quickly went to work. Peelers were cut up and sinkers were attached to our leaders. We very methodically set our four rods out in search of anything that would bite. Just as we cracked our second beer, Bobby's outward line started to move off at a steady pace. His demeanor turned serious as the line came tight and a "broom-like" tail thrashed at the surface. After a brief tussle with uncertain outcome, the thirty-pound drum came across the gunnel and was deposited into the front section of the boat. I don't know who was more surprised, me, Bobby or the fish. It did spark a brief celebration prior to getting back to business.

Just as the tide began to turn, we freshened up our baits. My cast had barely reached the bottom when, with the rod in my hands, the line quickly came tight and drag began to peel off the reel. I simply held on until the brute finished its first run, then began to apply pressure to begin the retrieval. From the outset, it was clear that it wouldn't be a quick or easy process. We'd hooked the fish on the far port rod, the first run had been fairly straight away and now the fish was working its way into the current, making a slow circle from left to right. Rods were cleared and re-deployed behind the hooked fish in hopes that he wasn't traveling alone. With bent rod in hand, I stumbled around and over coolers, rods, bait, Bobby and whatever else was in the smallish boat. As I stepped across the bench seat into the front half of the boat, things were settling in for a bulldog-style fight. Bobby stood, splitting time between watching the rods for a third bite and watching me fight the fish.

The beast made a sudden run toward the setting sun, and I bent forward due to the pressure of the fight. The button holding up my shorts popped off and fell into the water as I strained to control my fish. Pulling the rod back from the four-o'clock position to a more overhead position in an effort to stop the run and recapture some line, my shorts fell around my ankles. There I stood, with both hands occupied fighting an eighty-pound black drum in five feet of water and bare-assed to the world. I really didn't care about losing my shorts. I did care about losing the fish. Pumping and reeling with a steady pattern, I asked Bobby to pull up my shorts. I didn't think much of it, but it did give him some pause. Rightfully so, I suppose. After

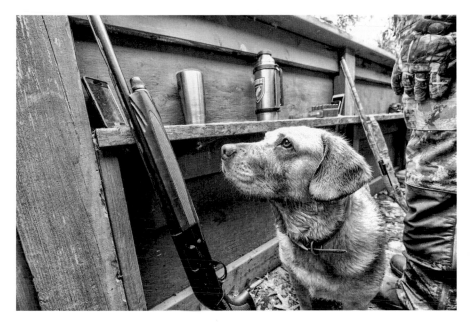

No, Codi isn't checking her Snapchat. She's tuned into the next flock of incoming geese. *Paul Bramble photo.*

some discussion, I surrendered the rod and secured my shorts in their correct postion with a belt fashioned out of a piece of stern line.

Laughing hysterically, Bobby returned the rod to me upon request, and I resumed the fight. The exhausted fish came boatside and was aptly secured in the net. A fat eighty-pounder was added to the catch as we laughed heartedly about our experience. We still had three rods out, as we thought that this bruiser most likely wasn't cruising the shallows alone. Sitting on the middle seat, I grabbed a beer while tending to my fish-finder rig. In the midst of our good-hearted ribbing, we hooked a third, then a fourth. The ensuing dance around the smallish boat as we battled the doubleheader was made more difficult by the pair deposited in the front of the skiff. Utimately, both succumbed to the pressure and joined their friends for a boat ride back to Saxis Harbor. With the sun now kissing the lower bay, the decision was made to pack it in. The skiff wasn't equipped with navigation lights, a result of another brutal duck season. The ebbing tide and decreased winds made the ride back to Fishing Creek tolerable. Idling up to the ramp, Bobby would hop up on the dock and get the truck while the boat in front of us was loaded. Two anglers peered down from the walkway, some four feet above our boat, as Bobby scurried up the ladder.

Those four fish laying in the front of the boat looked huge, as the tail of the larger one bowed up and hung over the gunnel. The onlooking anglers couldn't get over the fact that those fish were caught in that "little" boat. The questions came at us in machine-gun-like fashion. We kept tight-lipped. From that day forward, whether we were hunting, fishing, clamming or cruising, the little aluminum johnboat was dubbed "The Drum Boat."

Those three words can't be said without a chuckle and thinking back to that eventful afternoon.

ALONE, BUT FAR FROM LONELY

His hunting escapades had now turned into predominantly solitary pursuits. Gunning partners for the better part of sixteen years, his boys had grown into lives of their own. Many of his friends had real jobs that occupied most of the few wintertime daylight hours. They looked forward to the weekend to get their time in the blind. He'd always hunted and chose careers that would allow it on a daily basis. Operating a little outside the norm, he'd made a living while ensuring enough downtime to quench his outdoor addiction. Time and age had crept into his life, but neither of the two affected his desire.

After the last of the kids moved along, the first couple of years were difficult to endure. Time spent cleaning and rigging the decoys, pouring weights or working on blinds had been considered quality family time. He missed the help, but he missed the comaraderie more. While he placed the dozen teal decoys into the gray plastic tub, thoughts of past hunts intertwined with plans for the coming morning. Six hand-carved black ducks were gently placed atop the plastic, hollow teal. Tomorrow's effort would mark his seventeenth trip of the season. It would be another solo mission.

There was no need to set the alarm clock. He'd gotten up at the same time for the last thirty days. In that time, each morning had been spent either gunning or scouting. The morning ritual was well established. The boat had been readied and hitched the night before. There wasn't much need to get the gunning clothes ready. Most likely, if they weren't wet, they'd be recycled for several days. The dog was waiting at the door. She'd been

part of this drill before. A quick loop was made through the garage to grab the gunning bag, cased guns, bibs, boots and coat. Depositing those items in their allocated spaces, he quickly turned his attention to finding coffee. The dog was already waiting in the passenger's seat. He pulled into the Goose Creek parking lot. The thermos was emptied of hot water and refilled with steaming hot coffee. With a full thermos and full cup in hand, it was now permissible to continue with the day.

During the fifteen-minute trip to the boat ramp, he began to wonder why a man of his age would continue to subject himself to the grueling ritual that most men many years his junior would find, at the least, difficult. Sipping on the hot coffee, he planned the morning's hunt in his head. He had a good idea of what should happen, but those plans are often folly for the duck gods. If he were a younger man, he'd be making the three-mile hike across the Free School Marsh to a freshwater pond called Lighter Heart. Black ducks, fat mallards and widgeon were attacked there without mercy in his younger years. In his youth, the return trip was routinely made more difficult by the weight of the bag. Age had now taken away some of those options, but with age came a wisdom that youth doesn't posess. He knew that the tide was low and on the come and that the southwest winds would be pushing additional water on the west side of Messongas Creek. This would allow early access to the food-laden shallows within the marsh. Other hunters, if there were any, would surmise that the tide would be too low for such an endeavor.

Arriving at the boat ramp at the end of Hammocks Road, it was plain to see that he was alone, again. He launched efficiently, and his dog was waiting in the boat as he climbed aboard. Three pulls on the cord, and the old two stroke Yamaha sputtered to life. Clipping her up on the shallow-water drive, he eased out of the harbor. He was out long before any other hunters would normally show up. Though he was the only one headed out on this typical Thursday morning, he was not alone. He had his dog, and the thoughts of past hunts entered and left his head like clouds across a western sky. About one hundred yards, out the shallow-water drive was disengaged. With a little coaxing, the boat came up on plane nicely.

He stood at the stern with the PVC pipe tiller extension firmly in this left hand. The run to Broad Creek was fairly easy. Along the way, he thought about the blue bills he and his father had killed in Round Cove years ago. A couple hundred yards farther down the bank, one of the points jutting out in to the creek was the site of an airhole where we slaughtered the blacks on a low tide January morning nearly thirty years ago with a college roommate.

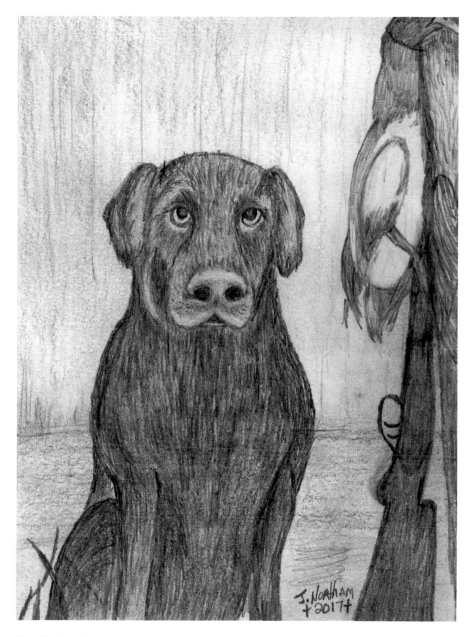

Joyce Northam drawing.

Lost in his thoughts en route, he instinctfully held the aluminum johnboat well off the area known as Cambodia. Having hunted there for the better part of his life, he knew of the stump field that lay just under the water near the shoreline. Found once by accident, it was now remembered religiously as he rounded North Point.

Slowing as he entered the mouth of Broad Creek, he swung wide to the right as he entered the mouth of Long Pond Gut. Once inside, he found ample water, provided by the southwest wind. Idling slowing, this lower unit gently bumped one of the numerous pine stumps. Getting up to the larger flat area, there wasn't sufficient water to operate the motor. Quickly, the kill switch was hit, the motor tilted and a fourteen-foot oak push pole was produced from the port gunnel. The pole felt very familiar in his hands. As the four-inch blade met the sandy bottom, he leaned a little against the handle of the pole. The pressure created by his force and the hard sand bowed the middle of the pole, providing additional spring as the boat lept forward.

This pole, like several before it, had been made with exacting precision for situations just like this. Frankie Kirwin of Mardela Springs had made the pair that he had used for the better part of two decades. With Frankie's passing, he'd just commissioned Keeford Linton of Saxis for the pair that he hoped he'd use for the next twenty years. Consisting of a knob on the handle end, it transitions to a rounded shape for the first four feet of its length. He had its handle trimmed to a diameter of three inches. At that point, it begins a gentle change from round to a "flattened diamond" shape resembling the blade of a standard paddle. Made from white oak and treated with linseed oil each year, it's a little on the heavy side, but it'll take the punishment he will dish out for many years to come. Such handcrafted items, like their makers, are rapidly disappearing. Poling along the small creek on a gentle incoming tide, he quickly covered the two hundred yards to his old scrag blind. Permanent blinds are prohibited in state-owned areas, but the collection of twigs, sticks and miracle bushes blended perfectly with the surroundings. It also provided a much more comfortable place to gun than either a layout blind or pop-up blind on a skiff. Outward appearance gave the impression that its shoddy construction wouldn't last the night, but in actuality, it'd been there for eight years now.

He dragged his pole along the bottom, and the boat slowed and turned slightly to port. Not wanting to venture farther up the creek, he slipped a small grappling over the stern. The boat stopped just upwind from the blind. The dozen teal were dropped around the boat in a small group. The

wooden black ducks were gently tossed in pairs downwind of the teals just in front of the blind. He chuckled as he picked up the third black decoy and heard the kernels of corn in the hollow body bounce around. His dog's ears perked as five teal buzzed the decoys. The time was drawing near.

The anchor was quickly retrieved, the boat spun around and, with several short strokes of the pole, the boat was headed back against the tide. He stuck her in a small gut and tied the painter off to an old stob that'd been left there years ago just for this purpose. The old A5 was uncased and promptly loaded. With his gunning bag across his shoulder, he and the pup began to make their way back to the blind. It was about a one-hundred-yard walk through the highest available ground. The pup explored every inch of the well-worn path though she'd been there several times before. Stepping in the blind, he quickly noticed that his seat had disappeared. Casting a beam from the Streamlight around the immediate surroundings quickly located the painted five-gallon bucket.

Though alone, he habitually positioned his seat near the right side of the blind. His old round-knobbed A5 was, as always, just to his left side. With that, the young dog began to settle in to the left side of the blind. Sunrise wouldn't come for another hour. From this location, he could see the outline of the bluff that marks Lighter Heart. It's a spot that he'd like to visit once again. Pouring coffee, he glanced toward the old gun and the new dog. The gun had been with him for more than thirty years. It's seen him perform in his prime. It had sat for unending hours patiently waiting to be called on to do its job. Only once had it failed to do its job. The dog, on the other hand, had just one season under her belt. She was green, eager and blessed with a good nose. There was much for her to learn; unfortunately, much of it would be picked up through failure, harsh words and repetition. He chuckled as that thought crossed his mind. It reminded him of his youth.

He sat sipping coffee engaged in a one-way conversation with the pup. Her hazel eyes were fixed on his every word. Watching the marsh come alive was now one of the things he loved most about gunning. Wings whistling overhead, the early-morning quacks of hen black ducks and the stillness provide a sense of solitude. His trance was interrupted as two objects appeared just over top of the needle grass sixty yards away. Rather than quickly duck behind the blind, he remained calm, wedging his coffee cup in the branches of the blind and filling his left hand with the checkered forearm of the Browning. At thirty yards, the pair of black ducks set their wings and began to approach the decoys. It was early; he knew that if

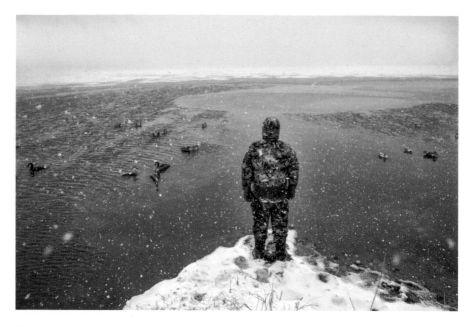

Even in the most bitter conditions, waterfowl hunters find optimism, hope and beauty that those who opt out will never experience. *Paul Bramble photography*.

they ducked below the needle grass, he'd have a hard time seeing them. At twenty-five yards, the recoil pad found its familiar spot on his shoulder and, once again, the gun was called on. She belched fire twice. One duck he was sure he rocked. There was a question in his mind about the fate of the second.

The dog's ambition would be tested. She went enthusitically into the darkness, guided only by mutual trust and given direction. She came across the first one, dead in the decoys. At some point, a couple years from now, she'd be called off that bird to find the cripple. He took the bird in hand. The second took much more effort. He felt certain the bird was down. For the next hour, he worked with the dog until the bird was finally found, quite alive. It had hit the water and swam nearly one hundred yards up a small gut. It was was found well hidden under the marsh grass. The morning's training exercise had paid huge dividends. Trust had been gained by the dog in his master, and by the old man in the pup.

The sun had now risen on what looked to be a warm winter's day. The few ducks that flirted with the decoys during the last hour were no longer our primary concern. He didn't return to the blind, but instead found his way back to the skiff. The last of the decoys were picked up and his

gunning bag and thermos were placed in the boat. The two began their trip back home.

The young pup enjoyed the wind in his nose. Looking down at the pair of black ducks lying on the middle seat, he was pleased with the results of the day. He'd shot fair, and his new partner had demonstrated the willingness to finish the job. There was certainly a time when he'd headed back to the blind to add to the bag. He could have been upset with the morning's bag, but those days are behind him.

Like Scarlett said, "After all, tomorrow is another day."

OLD SCHOOL ROCKFISH

There seems to be something magical about the first cool days in October. The slight chill in the air signals that it's time to put the stress of the summer's chaotic pace in the rearview mirror. As the days shorten and the water temperature begins to drop, fishing in the Chesapeake Bay is at its best. Resident fish begin to forage heavily in preparation for migration out of the bay. Those kindred spirits who live to cast artificial lures take to the marshes, shallows and channel edges searching for much more than just fish.

To many, tricking a fish to eat a manufactured imitation of their favorite meal provides more satisfaction than just that of coming out of the fryer. Searching the shallows for feeding fish becomes a hunting experience. We search for prime habitat. On afternoon ebb tides, as the warmer water drains from the marshes toward larger, more navigable guts, the down tide side of these feeders should always hold a fish. When locations such as this don't prove fruitful, it is baffling and often disappointing. Yet, we cast and cast again.

As October gets toward its end, a transition in fishing is made, from within the marshes to the surrounding shorelines. Within the perimeter of the marshes, rockfish make up for their lack of size with sheer numbers. Smaller offerings are eagerly devoured when pitched to any type of structure. Stumps, points, eddies, dropoffs and draining muskrat leads all are excellent places to find fish feeding greedily on the morsels being swept to them by the outgoing tide. It was just this scenario that I planned to take full advantage of on a crisp, late-October afternoon.

The larger Pursuit cuddy cabin was not the boat of choice for such skinny water endeavors. The old riveted aluminum johnboat would again be put into play. Low-sided, light and with the ability to slide up on the marsh, it would be covered with mud and, hopefully, fish slime by nightfall. Getting it ready is a fairly simple proposition. A pair of light-action spinning rods, a box of rubber fish and lead heads, a net, a cooler and a couple gallons of fuel are all that's required. It's a low-budget operation. In all of five minutes, the gear was loaded and hooked to the Tahoe, then sent rolling down to Pitts Creek boat ramp. Hatching a plan as I drove, it appeared that I'd have a falling tide during the hour and a half that I'd have to fish before dark. With little wind, it looked like a very promising afternoon.

At the intersection of Wagram and Holland Roads, a Tapman's Refrigeration hybrid truck bounced along in front of me. I immediately found Toby's number, and the call was immediately answered. He agreed to meet me at the ramp. I asked him to bring a couple of beers. As he arrived at the ramp, I had the boat launched and idling. He quickly hopped aboard, and we were off. We began making casts at the ramp and continued to cast to points, guts and other places known to harbor fish at the mouth of the Pocomoke River. Hitting a little dry patch, we elected to make a run to Bullbegger Creek. At a place where we had absolutely pounded the ducks in past years we found strong numbers of rockfish. All, however, were sixteen-inch clones. We slipped down to Double Ditches and fished the mouth of each of the two large guts emptying their contents into the Pocomoke Sound. There we found more of the same. Tremendous numbers of fish were eating everything we tossed in the general direction. The size remained the same. We had yet to find a fish meeting the twenty-inch minimum.

We hatched a plan to cross the sound in attempts to find fish suitable for frying under Pig's Point. The wind had fallen out, and the bay was slick cam. Just up on plane, Toby produced a pair of Bud Lights out of the cooler and twisted off the tops of the bottles. There's nothing quite like that first pull off a cold beer on an afternoon fishing trip. To the west sat Fair Island. Locally known as William's Point, it's a popular gathering area for locals in the summer months. There, many cold beers had been consumed, pigs roasted, chickens smoked, burgers barbecued, wars started, uprisings quelled and the occasional call for stud service answered over the preceding four months. The eastern end of this small sandbar had a very visible rip coming off it on this full ebb tide. It looked like as good a place as any. We thought we'd give it a try.

A fat, thirty-inch rockfish fell victim to a well-presented white bucktail and worm in the Pocomoke Sound. *Paul Bramble photography*.

I'd fished there several times at this time in the year, with no success. The few fish I'd pulled from there had been of the same sixteen-inch class that seemed to be everywhere in the bay. That's exactly what we expected to find on this day. But we were here and decided to give it a whirl before heading to our primary destination of Pig's Point. From there, we planned to work our way down toward Jack's Creek. Slowing as we approached the point to survey the area, Toby decided to go "old school," tying on a white three-fourths-ounce bucktail tipped with white worm. I opted for a pearl-colored, gray-backed rubber fish with a half-ounce lead head. My first few casts went unanswered. While making my fifth cast with no fish to show for it, I was wondering just how long we should try this. Toby was just getting his rig tied, so I thought I'd give him an opportunity to toss a few bucktails before moving elsewhere.

Casting off the back seat, with my back to Toby, I was focused on the little swirl of water coming off the back side of the point. I heard his drag begin to peel off at a regular pace. My first thought was hooked into a crab pot, signaling an opportune time to leave in search of more productive ground. His next comment got my attention. He was hooked into a good one. After several minutes of give-and-take, a fat, twenty-six-inch fish fell from the net

onto the floor of the skiff. His next cast yielded another fat striper. As did his third. I still hadn't had the first bite. When he hooked up on this fourth consecutive fish, I immediately went to the tackle box and tied on a three-fourths-ounce bucktail and tipped it with a white rubber worm. If it was working for him, it certainly should work for me.

Positioning the boat within casting range of where he'd caught the last four fish, I slipped the anchor over the stern to hold us in position. Our next two casts yielded a fish apiece. These fish were right where they should have been on the downtide side of the swirling ebb tide working around the point. These fish were not the standard sixteen-inch "cookie cutter" fish that we'd caught to this point all season. There was no need to pull a tape on them. Each was fat, healthy and clearly a new arrival to the location. The tide was running strong, and these fish were on the bottom. The heavier bucktail was the ticket to successfully catching them.

Our old school bucktails were just the trick.

PINEY HAMMOCKS

If it had been a summer day and I was planning on going fishing, I would not have launched my 21 Pursuit. However, it was late January, and the twenty-five-knot northwest winds spelled a good day for divers. Sitting in the truck at the dock, we waited for daylight to see just how much the winds would increase as the sun broke over the horizon. The coming light brought us the advantage of sight, and with it we decided to give it a whirl. The lines of divers crisscrossing Messongo Creek aided us in making that decision.

We submerged the trailer in the water, and the sixteen-foot, riveted aluminum hull floated effortlessly off the trailer. My partner for the day, and for countless trips over the last thirty-one years, Bob Bloxom tied off a quick half hitch to hold it in place. After parking the truck, I slowly walked back to the boat, surveying the situation. We had a good flood tide working, and I'd be able to tuck closely under the bank all the way to North Point. From there, it would be a mess crossing the open water at the mouth of Broad Gut until we again found the shelter of Tunnell's Island. Repositioning the load in the boat, we struck off for Piney Hammocks.

Piney Hammocks is a cove making up in the far reaches of Tunnel's Island. Our box blind was positioned on a point inside a small cove. It was just at the low-water mark and wouldn't be entirely sheltered from the harsh winter winds, but we thought it'd be an excellent spot to find divers. Our thought was that they'd be trading up and down the lee shore and we'd be in an excellent spot for an ambush. All we had to do was get there.

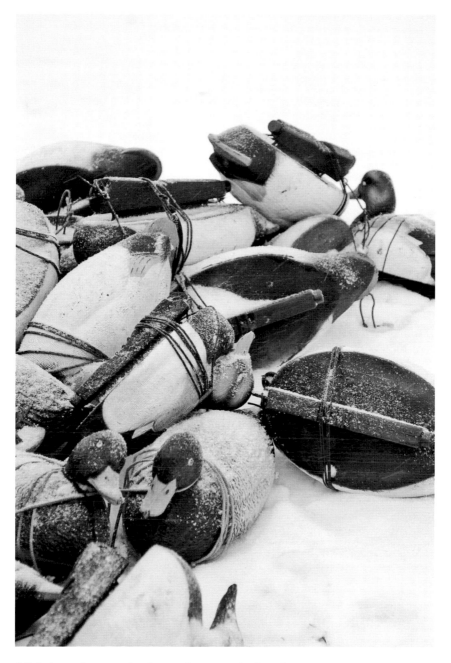

A little ice and snow makes for excellent waterfowling. These diver decoys had been switched out for a rig of puddle ducks. *Jim Lewis photo.*

Making our way out of the protected harbor, we quickly learned just how tough this trip was going to be. It was a three-hundred-yard run to the protection of Free School Marsh. By the time we found calmer waters under its protection, both of us were already wet with salt spray, and the bilge pump was in full operation. There were no leaks in the boat, but we had taken on a significant amount of water over the bow. Turning around would have been more dangerous than continuing our path as the waves continued to pound the small craft unmercifully. Finally, we found calmer waters and turned parallel to the bank. Running not more than ten feet off the marshy shores, the ride was fairly calm and uneventful. Rounding the point just past Cambodia, we faced the harshest part of the ride. I chose to deadhead the three-foot chop for one hundred or so yards before turning broadside for the last leg of the run. It was a wet ride. Operating the tiller with my left hand, I had my back to the spray, occasionally peeking out from under my oilskin coat to adjust our course. After a short-ass whipping, we again found shelter under Spartessa.

Under the shelter of the bank, we began to attempt to get our gear back in order after the hellish crossing. We only had a half mile to go; the hardest part of the jouney was now behind us. From what we could see between showers of saltwater, it looked like we'd have a decent opportunity for some stellar shooting. Since the tide was up, I elected to cut just inside Scarborough's Point into Back Cove and snuck up on Piney Hammocks from the back side. Nosing the skiff on the bank on the windward side of the blind, we quickly unloaded our gear. While Bob got the blind ready for action, I tended to the decoys. The wind was too strong to simply drift and set the rig. I anchored just upwind of the blind and began to toss diver dekes in a pile in front of the blind. In these conditions, there'd be no hook or similar decoy scheme. We felt we'd be successful if we could just get them in the water.

This was no day for a large spread. Two and a half dozen assorted canvasback and bluebill decoys were put into service in very close proximity to one another. With twelve feet of line and a one-pound weight on each decoy, we hoped that we wouldn't have any drag. They would certainly be put to the test on this day. Pulling the anchor, I eased to the outside of the rig to inspect it. One decoy had already broken loose, most likely separated from its weight by my prop, and began to drift quickly to the rough waters of the open bay. After retrieving it, I stuck the skiff in the cove just north of the box. It was made fast by a double half hitch to the pole stuck deeply in the soft marsh mud, backed up by the anchor with twenty feet of rode.

Stepping into the blind and latching the door, Bob handed me a hot cup of coffee. It was certainly welcomed. He had the guns uncased and loaded. As we savored the hot beverage, our first visitors of the day came knocking. Coming from up Messongo Creek, the pair of cans rounded Scarborough's and made a beeline for our decoys. Their direct flight was just above the white caps. At about eighty yards, they eased off to the downwind of the decoys, then turned into the wind on their final approach. We just let them keep coming. The shot was called as they crossed the decoys looking for a place to settle in toward the front of the pack. It was as pretty a left-to-right shot as anyone could ask for. As they bobbed belly-up in the decoys, it became clear that retrieval of the downed birds would have to be a very quick affair. As I watched them quickly drift through the decoys, a flock of more than a dozen bluebills worked toward us, following the same path as the two cans. Calling the shot a bit too early, we ragged out three. The swimming escape attempt of the closest drake was thwarted by a well-placed load of # 2s.

I quickly moved toward the boat, hoping to retrieve the five downed birds before they got to the open water of the bay. From the high ground, I could see that they were drifting quickly. With haste, the anchor was freed and gently tossed into the boat. As I was untying the bowline from the push pole buried into the mud, Bob cut loose three shots in rapid succession. Two more bluebills were added to the floating line of ducks. I got the boat up on plane, making good time toward the bobbing cans now nearly a hundred yards off the shore. The bow of the boat slammed into the back of a stout three-footer. The sudden deceleration nearly threw me to the floor. The two cans now drifted about twenty-five yards apart. The first was plucked from the icy bay water with a gloved hand. Seconds later, the second was also tossed into the bottom of the boat.

Just prior to making the turn, the first wave crashed over the stern. I instinctively twisted the throttle counterclockwise, adding speed to the skiff in hopes of avoiding disaster. Turning broadside to the wind and waves, it took on the top of the next oncoming wave before I could turn its bow into the seas. Moving slowly, head to the seas and against the wind, the little boat was definitely overmatched. The trusty five-gallon bucket was put into service ridding the boat of water at a feverish pace. Slowing the progress of the boat brought it bow down. The two dozen decoys in the bow provided adequate ballast to level its attitude. I continued to bail. After a couple of minutes of uncertainity, the situation became more

manageable. Reaching for the dip net, I continued to make way toward the blind while dipping the remaining birds from the water.

There was a feeling of thankfulness when I reached the waters sheltered by the bank. Pushing her bow up on the sand behind the blind, I quickly tossed the anchor into the marsh grass and resumed clearing the boat of excess seawater. Bob had witnessed the ordeal and realized the danger. He'd passed on several shots while I was trying to stay afloat. Upon my return to the box, we agreed that no bird was worth the peril of retrieval, and without the opportunity to retrieve them, there was no point in continuing our hunt. We sat drinking coffee and watched flock after flock of canvasbacks, bluebills and hundreds of buffle heads come and go. It was agreed that today was no day for us to be in this place.

As the wind increased, we decided that we wouldn't risk the run back to Hammocks. Instead, we opted to hug the bank along Tunnells Island, then cut into the sheltered backwaters of Back Creek and make our way through the labyrinth of small creeks to the safety of Saxis Harbor. We'd tie up at the local breakfast spot and catch a ride back to the truck.

On the ride in, we both were silent. We both knew that we had got lucky on this trip.

13

PLAN B

The waterfowl season was grinding on like many before it. Mild weather had dominated the majority of the season and limited our excursions to chasing teal, woodrows and assorted puddle ducks in the shallow waters and back marshes. As with most years along the Atlantic Flyway, the best weather comes during the last few days of the season. This year would be no exception.

The cold snap hit the Eastern Shore of Virginia with exactly seven days left in the gunning year. During the first few days of it, we were blessed with northerly winds, often gusting to thirty miles per hour. Divers of all sorts—orange-legged black ducks, geese and flocks of mallards—moved from their snow-covered northern stopovers to our locale. The hunting had been outstanding. Hunting on the lee shores of the larger creeks and bays had yielded huge dividends. On the higher tides, we alternately shot canvasbacks, bluebills and the occasional goldeneye. As the tide fell, we swapped out the diver rigs for smaller puddle-duck rigs.

After three days of continuously hunting these new arrivals, the winds moderated and the clear, cold, calm nights caused the water temperatures to plummet below the magic number. Ice began to form. Starting first on the windward shores with the frozen, windswept waves, the cold then knitted across the bays and channels, forming a firm barrier to normal boat traffic. Being anything but "normal," we continued to utilize our larger fiberglass-hulled scows, and the occasional workboat to bust a track that would allow access to numerous locations where, historically, we'd visit in such conditions.

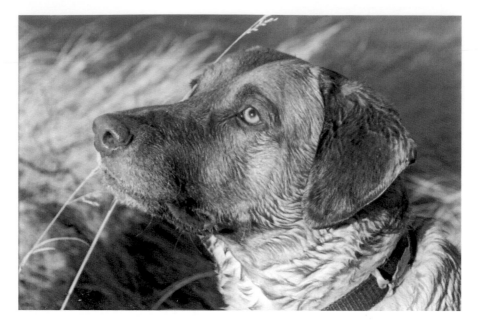

Butler often saw the incoming birds long before we did. Here, he's staring at a pair of black ducks that have no interest in our little spread. *C.L. Marshall photo.*

Success could be found at what the old-timers called "air holes." These were primarily areas that would stay ice-free due to high current or points where the ice would move off the bank on high water and strong northwest winds.

With three days left in the season, these options were eliminated. The ice was too thick, or piled up, to safely bust through. The normal "air holes" would remain covered with ice. We started looking to the fields for an appropriate way to end the season. There were a good number of birds picking on the waste grain, but those fields were off-limits to us. It looked like a grim way to end the season. Finishing the year sitting at home is agonizing.

The weather would warm to above freezing for the last day and a half of the year. My youngest son was forced to miss many of our weekday trips due to his obligations at school. He was looking forward to a Saturday hunt to let off some of that adolescent steam. I was scrambling to find a place to take him.

The only real plan we had at our disposal was to take a gamble on a larger workboat busting out of Saxis Harbor. Our calls the night before went unanswered, as most people had simply thought better of it and made other plans. Ever the optimists, we had loaded the boat the night before, rose early and headed to the marina in the predawn hours. It became quickly apparent

that there would be no other fools heading out of there on this final day of the season. Sipping on hot chocolate, I recalculated our options. There was one that I had overlooked. Just before 6:00 a.m., I shot a text to Benny Hall Jr. He fired right back, saying that he had a piece of open water and that we were welcome to join him and Tom Hart—as long as I brought my dog. Thanking him, I set out for our rendeavouz point. The skiff was dropped by the shop in Sanford en route to Makemie Monument.

I could see Ben's truck along the edge of the field bordering Holden's Creek. Since the ground was frozen rock-solid, I eased across the field. He and Tom had constructed a rather nice bush blind along the shoreline. We would be sheltered from the strong northwest wind by the high banks of the field. We'd be gunning over a bend in the river where the water flowed at a furious pace. We had more than an air hole, we had nearly a hundred yards of ice-free creek. We quickly unloaded our gear into the blind, along with a couple of bags of decoys. We wouldn't need many.

Gunner, my golden retriever, jumped back in the truck with me and my youngest son, Parker. We went down the blind to assist in wading the decoys out to their proper places. In this cold weather, they needed to be placed, not tossed. Tossed decoys would undoubtedly ice up quickly. That icy sheen would not be conducive to our plans for the morning. As Gunner and I were walking back from hiding the truck, I could see fast-moving forms trying to get into our little bit of open creek, only to catch the wind and bank away, flared by the activity around our blindsite.

Tom Hart, ever the gentleman, told Parker to take the far left side of the blind, which would see the most action during the morning. Tom settled in next to him. I sat by the door with Ben to my left. Gunner took his perch in the reeds by the door. The guns were quickly loaded; the action began almost immediately.

A pair of fat mallard drakes flying up the creek banked hard to the right, set their wings and hovered over the decoys. Tom and Ben had already relinquished the rights to the first shot of the day to Parker. They hadn't hunted with him before and saw only a twelve-year-old boy along for a hunting trip. Allowing him the first shot was the right thing to do. "Kill 'em, Parker," Tom whispered. Parker's Browning Maxus barked twice, and he did just that. As the second fell from the gray sky, Tom congratulated him on his good shooting. He was undoubtedly pleased to see the young hunter kill an outright double, but his surprise was also evident. Gunner made short work of the double.

As Gunner was about to climb ashore with the second bird, a single black duck dropped over the cedar trees on the far side of the creek. With locked wings, she veered a bit toward the left side of the spread. Again Tom called on Parker to take the bird. A single shot punched his ticket. Right on the heels of the black duck, three teal soared by in the middle of the creek. The two shots left in the Maxus claimed two more teal.

"Oh…I see, it's on now!," Tom said as the second teal cart wheeled across the surface of the water. "You all didn't tell me he'd done this before!"

Our laughter and ribbing went on for several minutes, scaring the crap out of a flock of teal that were trying to settle in to our decoys. Regaining our composure, we spend the better part of the morning alternating shots on mallards, blacks and numerous flocks of green-winged teal. Gunner was earning his keep.

Just before 8:00 a.m., I placed the call for breakfast to be delivered. Twenty minutes later, the Food Truck came rolling across the frozen bean stubble. Gunner and I met the truck at the edge of the field as our three companions continued to cut loose on puddle ducks. There's nothing quite like hot coffee and a fried bone-in porkchop sandwich. No buns, only Sunbeam white bread. It is the perfect duck blind food. There was no need to share with Gunner. He had his own.

After the first two shots, it became evident that our young guest could shoot as well as the rest of us on that day. But none of this would have been possible without hunting partners willing to share the experience. Our day ended with a full limit of ducks and a pair of geese apiece. Gunner had spent nearly the entire morning in the water and was pleased to curl up in his blanket on the back seat of my old Tahoe. Our "Plan B" turned out to be an excellent option.

POKER, GOLF AND ALCOHOL

It's a relatively small building. Driving past it, most people would find it relatively unremarkable. Many wouldn't even notice its existence. For the hundreds who have crossed its threshold, it will remain a place of good memories and hope for the future. Many a good meal have come from the doors of the kitchen. Thousands of decoys have come from the little carving area in the back.

We acquired the little shack across the street from our main domicile in the mid-1980s. Carson Long, the elderly fellow who owned it for as long as I can remember, had passed on, and we purchased it from his estate. At the time of the purchase, it consisted of only two rooms. There was a small kitchen, a bedroom and no indoor restroom. He'd been passed on for a few months before we could get in there to begin cleaning and renovation. The old fella smoked nonfiltered Camels, lighting one with the other, for nearly all of his days. The windows and walls were covered with a thin film of sticky, yellowish smoke residue. We decided to remove the wallpaper. There was no way to get that smell out of the house.

We began to make the little shop our center of hunting and fishing operations in the Sanford/Saxis area. The lot was cleared to the maximum area allowed by law, and fill was brought in to establish a driveway and boat parking area on the west side of the house. With the help of a local farmer's equipment, our staging area was set on high, firm ground. Inside, the little building began the transformation into a place where we could gun, fish and kick back with little worry about being infringed upon. The single bed in the

In order to prepare a whole roasted duck, a little elbow grease is required. Marlene "Gone Postal" Marshall is pictured making quick work of a wood duck. *C.L. Marshall photo.*

front room was eliminated in favor of twin bunks. While we were interested in developing the little hunting shack to its full potiential, money was always an issue. For heat, we added a five-brick gas wall heater. New to us were an apartment-size refrigerator, gas stove, stainless sink and butcher-block countertop. All of these were scavenged from area thrift shops.

Our major investment was the addition of a sixteen- by twenty-four-foot addition on the back of the building that doubled our square footage. Not only would it provide my father the carving space that he so desperately needed, but it also afforded us an area to stow hunting gear and dry it between hunts. The best part of the new space was the ability for us to relax, have a sandwich and enjoy a drink or two after the trips. That is what most visitors to "The Shop" remember.

No October rockfishing trip would be complete without stopping in. When the bite was on and we planned on fishing the same general area numerous times over a short period, the boats were simply left there on the hard. There's nothing quite like a fresh fillet of rockfish drudged in House Autry seafood breader and fried in a cast-iron pan. Sandwich this fillet between a couple pieces of white bread, and we have a meal fit for a king. But in that little piece of heaven, we are all kings. The feeling of

total relaxation, free from the encumberances of our daily lives, joined by kindred spirits charged with simply enjoying what the area has to offer, is a rare one. Yet this feeling comes over each of us every time we walk though that green door.

On one such sunny October Monday, the calls began circulating before the dew got off the grass. There was no need to involve the weatherman. The bay was slick cam, and the tide would turn to ebb in the early afternoon. It was no doubt where the rockfish would be schooled up. Plans were made to meet at the shop at 11:00 a.m. We'd leave the dock at high noon. Most folks in the golf business were off on Mondays, and we planned to put this day to good use. The roster for the day's event included most of the staff from Eagle's Landing. Andy Loving, Tim Brittingham, Neal Mauer, Hess James and Bobby Croll made the trip to meet me in Sanford. After a couple of preliminary cocktails, we began to lob wedges over the boat toward an empty five-gallon bucket. Neal pocketed the thirty dollars on his third attempt. Plans were made for redemption on our return.

Rolling out of Saxis Harbor with our fists around freshly made Malibu Black and pineapple juice cocktails, the *Chincoteague Island Sportsfisherman* was eagerly pushed up on plane by the Yamaha outboard. The fiberglass hull cut through the glasslike water, making a refreshing sound. We covered the 6.7 miles to our destination quickly. At a distance of about one mile, I could see the gannets. At two hundred yards, I could see the fins and tails of the feeding rockfish busting the flat surface of the water. Moving closer, I could see the fish pushing water, voraciously feeding on terrified bunker and just begging to be caught. Excited, I pulled back the throttle. My mind was already fishing. The others in the center console were caught looking at the fish as the boat suddenly decelerated. Hess and Bobby were seated on the bow seat. Andy and Tim each had a hand on the console and were able to brace themselves. Neal—all six feet, four inches of his lanky frame—was standing along the port side of the boat with a fresh cocktail in his hand. As the boat quickly slowed, Neal slowly fell forward, much like a harvested redwood, catching himself on a knee and his left hand on the floor of the boat. In his right hand, the cocktail remained full in spite of the fall.

After a quick laugh at his expense, we turned to the task at hand. The bottom machine displayed large red arches near the sandy bottom, signaling larger fish. The surface was littered with smaller fish fighting for their dinner. Our crippled herrings were sent to the bottom, where the big fish were waiting. Almost instantly we were on them. Fish after fish came over the rail as the five of us were catching fish faster than we could have ever imagined.

The clear bait of choice was the two-ounce crippled herring. Hess, ever the jokester, tied on one of my two-ounce black-on-black bucktails and tipped it with a white four-inch worm. Sitting on the bow, feet dangling in the water, Hess sipped his drink and chanted, "Come on, Mama-Duker!" time and time again. After a few minutes of this chant—and some well-directed ribbing—his rod doubled and the chant changed to an excited exclamation of, "I got the Mama-Duker!" The battle that ensued was nothing short of epic. The outcome was uncertain, as several times Hess nearly fell off the bow as the fish struggled to find safety in deeper water. We elected to use the net for this one. Hess's "Mama-Duker" turned out to be a fat, thirty-four-inch striper. It concluded our limit. We'd been fishing for all of forty minutes.

A couple more drifts were made as we caught and released another dozen or so fish. With that, we stowed the rods, killed the engine, mixed a fresh drink and drifted along with the outgoing tide, enjoying one another's company. The boat was given the usual Saxis Island washdown.

Prior to arriving back at the shop, our roles were clearly defined. Croll would skin the fish. Andy and I would get the kitchen production rolling. The others would get the boat back in shape for our next trip. In short order, the fried rockfish sandwiches were served on the newly added outdoor

Santa paid me a visit down at the shop in Sanford. By his account, I'd been a pretty good boy, and he promised to deliver a dozen new foam-filled canvasback decoys. *Bill Hall photo.*

deck. I could see that Andy was eyeing something. He wagered that he could launch a golf ball with his driver between two pine trees situated about 250 yards across the road, and in the marsh. The sandwiches were finished, wagers were made and the process was set in motion. Andy was not known for his length off the tee. We were forced to wait as the sportatic traffic on 695 forced several interruptions in this ordeal. Setting up on the ball as Mike Tull motored by in his silver Corolla, Andy said, "I'm a professional. I've got insurance against such things." With that, he lauched the Top Flite toward the pair of trees, but the fast-moving ball lacked any appreciable altitude. Though Mike's car was moving away and at a distance of only about one hundred yards, the ball seemed to move in slow motion as it made its way on a collision course with the car. It wasn't a matter of if it would hit the car, but where. With a thud, the rock-hard Top Flite struck the top of the back tire, just below the fender well, and bounced hard left away from the car. No damage, just a lot of luck. There was no second attempt.

Folks from all walks of life have joined us for food and drink at this little piece of dirt down in Sanford, Virginia. Relationships have been forged into lifelong bonds, and many new friends have been made sitting around in unmatched chairs on a floor covered with wood shavings. The combination of sparse accommodations, no cell or phone service and a feeling of remoteness all contribute to making this little place so special. After all, it's not about where one goes, but instead with whom one shares company that is the real important aspect of time spent afield. But a good setting sure makes it more enjoyable.

THE TIJUANA HILTON

The hard rains and cool temperatures of mid-December had played right into our hands. We hoped the ducks would do the same. On the banks of the Machipongo River sat a field where, many years ago, at the late Ronnie Kellam's request, my father and I had first experienced what a dove hunt should be. As the goose decoys were being placed on the far edge of the pool of sheet water, I recalled the story to my partners of the day, Anthony and Butch Thomas, and our host, Richard McBride.

Richard had recently acquired rights to the farm, which proved to be a very unique twist of fate. We'd successfully bow-hunted for magnum whitetails in the pine forest surrounding the grain fields. It's been the setting where many a mallard ended up in Gunner's mouth after visiting one of the four freshwater ponds on the property. The prior Feburary, we'd unleashed twenty beagles and hounds on cottontails in the brambles thoughout the property. Countless cocktails had been consumed in the nights preceding and after such hunts in his rickety gunning shack dubbed "The Tijuana Hilton." Trust me, it was anything but a Hilton.

The recent rains had flooded a low spot in the middle of the bean field adjacent to the shore's only seaside river. The lone pine tree under which Dad and I sat donning automatic shotguns still stood on the south edge of the field. Dead ahead, some two hundred yards away, was the shallow, muddy waters of the waterway. Just over ankle deep, it was the perfect feeding area for puddle ducks and geese. Our scouting had revealed its attraction to local waterfowl. Mallards love a flooded bean field. We intended to test that theory.

There was no blind in the field. Hunting out of the ditches was not an option, due to the recent heavy rains. Though we had few options, we did have a plan. Under the guidance of several Tito's and tonics, we hauled an old two-man box blind out of a field across the farm. We'd used it for deer hunting years before; it had sat unused for two seasons. After pulling it to the Hilton with the four-wheeler, we fired up the chainsaw and began modifications to transform the deer-slaying platform into a towable low-profile waterfowl blind. We cut the top off level with the front edge of the box. Still, we felt that was too tall. When we finished sawing, the thing stood only three and a half feet tall in the back and just over three feet in the front. We did away with the door to add rigidity. We would simply step in over the front of the box. Angled four-by-four skids were secured to the bottom of the blind to aid dragging it to the field. We fashioned a bridle on the strongest side to prevent twisting while in tow. There was considerable debate about whether to bush it here or wait until we got it to the field. We elected to wait, as there was a distinct chance that we would not make it to the intended site with the box intact. The tow to the field went very well, with only minimal damage to the box. Bushes were cut for cover and stuck in the mud around our chosen site. We decided to finish the chore in the morning.

Darkness began to descend on us, and we retreated inside to hatch our plan for the morning. The bottle of Tito's dried up, signaling time for our departure. Making our way back home under the cover of darkness, we were more than excited about the opportunity that lay before us in the morning. Plans were made to leave Pocomoke at 4:00 a.m. Our gear was quickly pulled together and stuck in the back seat of the truck. Anthony and I parted ways, agreeing to meet at the Royal Farms at the Maryland-Virginia line, where we'd pick up coffee, junk food and other necessary sundries. Just before 5:00 a.m., we arrived at the farm. McBride jumped in the truck, and we made our way through the maze of dirt roads and woods to a spot near the blind. Our decoys and gear were loaded on the sled and dragged to the blind. Anthony and I slugged through the shin-deep mud toward the blind. The two-hundred-yard walk was a struggle.

The decoys were quickly set, and we began to finish prep on our renovated deer blind. Settling in, it wasn't long before things began to happen. Overcast conditions and ten- to fifteen-mile-per-hour winds from the northeast contributed to what would be an excellent gunning day. Right at legal shooting time, a pair of blacks slowed over the decoys, being a little indecisive about just where they should set down. We answered that question

for them. Five mallards circled three times before dropping below the tree line. We lost track of the five as a pair of single black ducks lit in the decoys thirty seconds apart. They nestled in nicely and began to feed on the waste grain in the sheet water. Though we couldn't see the mallards, we could hear their feeding chuckles as they circled somewhere in the compromised light. A fat drake backpeddled by the flapping mojo positioned in the middle of the spread. His four friends were just behind him. We stood to welcome them to the party.

The fat drake was dispatched first. Eight more shots followed, belching fire out of the barrels. Immediately I was out of the blind, followed by Anthony, to handle the cripples. There were only two. Hustling over to the first fat mallard, the Mojo was knocked in the shallow water, rendering it useless for the rest of the day. The small pile of birds was neatly stacked by the back of the blind. Stepping back in, we heard the first goose of the day. They were low on the water and unquestionably headed our way. We just sat and waited. There was no circling. Their outstretched wings enabled them to glide toward the pocket of our decoys. The shot would be almost head-on. Two were killed instantly. The third took two shots to subdue.

Handmade decoys ride in the water much better than their mass-produced counterparts. It's a very nostalgic experience to hunt over decoys. *Jim Lewis photo.*

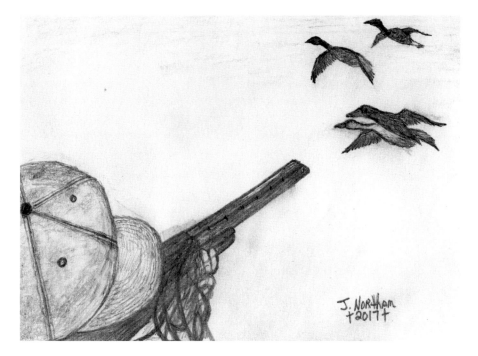

Joyce Northam drawing.

The morning continued along the same pattern. We alternated shots on geese and ducks until we had reached our limit. There was no need to push the situation. We had many more days left in this season and saw no need to shoot out our little piece of sheet water. Calling it a wrap, we decided to pull the blind back out of the field to the edge of the woods. The decoys were piled inside. Plans were made for an encore in three days. It was only 8:15 a.m. Our discussion turned to breakfast. Exmore Diner was the only viable option. Plus, it was locally known for the best breakfast in town.

McBride had a freezer full of fowl. Anthony needed a few, and Butch fed a few old heads in Sanford who loved fowl but, due to their age, were no longer able to obtain it for themselves. They truly appreciated the occasional gift of a well-fed duck or goose. We enjoyed supplying them. We tossed the birds in the back of our pickup and headed for town. We quickly found a spot and parked right by the door. Folks entering and leaving the restaurant peered and pointed into the bed of the truck at the impressive array of game we'd come across on this overcast December morning. Midway through our first cup of coffee, the waitress appeared with four plates of true Eastern

Shore lovin'. Our attentions quickly turned to the breakfast at hand. After some serious grubbing, we went our separate ways.

Rehashing our hunt on the way back up the shore, Anthony, Butch and I debated the number of hen mallards allowed by law in the commonwealth. While searching for that answer, I came across the seasons for Canada geese. My jaw dropped when I found that the season wouldn't come in for another five days. We had no idea and proceeded through our morning as if we'd done nothing wrong. Parked by the door with six geese out of season in plain sight, it was no wonder that several people pointed and peered into the back of the truck.

The truck was immediately pulled to a side road and the game properly placed out of sight. This time, we had been clueless to our wicked ways.

THE BARN

A recent discussion with a pilot of the Maryland Department of Natural Resources about changes in migration patterns of waterfowl in the Atlantic Flyway brought forth many things that I knew from experience but was ignorant regarding the science behind.

According to data recorded by pilots flying over the same habitat year after year, it's been documented that migratory birds are showing up on the Eastern Shore later each year. Some forty years ago, the peak migration of canvasbacks occurred between November 15 and December 1. In recent years, we can expect the largest influx in the waning days of our season, namely late January. Listening to him speak of the science behind what I was seeing in the field, and the reasons behind it, harkened me back to a gray Thanksgiving afternoon nearly thirty years ago.

As per usual on Thanksgiving morning, the Marshall clan loaded up and headed for Cattail Creek in the predawn hours. My father and I slugged our way down Messongo Creek, around South Point, due to the low tide and fair wind into the shelter of Cattail in our eighteen-foot Gaskill scow. The dawn broke, bringing us sun and a steady northwest wind of about fifteen knots. The gray skies to the north beckoned a weather change that would undoubtedly find us on the change of tide.

Our thirty-six floater goose decoys bobbed in a somewhat lifelike fashion around our island. A dozen or so stickups adorned the tump, with the majority on the downwind side. A dozen more puddle ducks, consisting mainly of blacks and mallards, were strategically placed

Carroll Marshall's working decoys have gained a strong following in recent years. His "old school" style and thicker bodies make them a favorite of discerning hunters. *Jim Lewis photo*.

upwind and inside the Canada goose decoys. In the minutes preceding legal shooting time, the air was filled with the sound of whistling wings and feeding chuckles as mallards and blacks busily went about their morning in search of food and reliable shelter. Just after the appointed hour, a single black took a second look at our spread. Positioned on the upwind side of the blind, I called the shot for my father. His round-knobbed Browning humpback preformed as expected. The bright orange

legs of the black duck bobbed in the short chop of the creek as the wind pushed the fallen bird toward the opposite shore. We were between dogs. I'd retrieve it upon our departure. Hopefully, we'd add to the collection on the far side of the creek.

The rest of the morning consisted of flight after flight of buffleheads, hooded mergansers, sea ducks and the the occasional late-rising black duck. None were interested in our spread. We sat talking about various topics that often accompany such a father/teenage son outing when our discussion of my academic pursuits was interrupted by the single honk of a Canada goose. It sounded close. Peering over the cedar branches that obscured our hiding spot, the goose was not readily found. A second sound from the approaching goose gave away his position. Stemming the wind and flying directly to the front of the blind, this single goose was on a wire. The goose was flying just above the marsh grass on the far side of the creek, emanating a single honk every twenty seconds. The flight path would take this goose directly to our decoys. As the goose crossed the boundary of marsh and water on the far side of the creek, he began to gain a little altitude. Now just eighty yards from the outer limits of our spread, we expected to see this goose cup his wings for a smooth landing into the pocket of decoy spread. He continued a regular stroke of his wings as he crossed the middle of the creek. As long as he was heading my way, I planned on letting him come. Reaching for the Lefever sixteen-gauge double that I was carrying on this day, I made ready for the shot. As I rose, the goose, still flying on a straight line that would take him directly over our blind, began an upward evasive maneuver. The right barrel of the double stopped the wing beats of the incoming bird and, immediately, gravity began to take over. The bird crashed into the front of the blind with a thud. With that we began the task of picking up our decoys. Dinner was at 2:00 p.m., and we were responsible for the oysters, clams and roast duck. The Hall family was joining us for dinner, so there was added preparation to be done. We needed to get rolling.

The wind didn't noticably increase, but the skies continued to darken to a very ominous gray tone. It *felt* like a good gunning day. On the trip in, we took a small detour by one of our blinds on the backside of Tunnells Island. Our visit jumped a fair number of canvasbacks. We left a little enticement to make certain that they returned. It was, after all, Thanksgiving.

Prep went well, and dinner went off without a hitch. As we sat sipping coffee and wondering about having another slice of pumpkin pie, a gust of wind rattled the windowpane of the dining room.

This decorative Danny Marshall drake bufflehead is done in the style of the Ward Brothers. Buffies are arguably one of the more popular targets for waterfowlers all across Delmarva. Many, however, won't admit it. *Jim Lewis photo.*

Bill Hall and I immediately looked at each other, thinking the same thing. With that, we announced that we'd be going for an afternoon hunt. I could see the strain in my father's face, knowing that he couldn't go but wanting like hell to join us. Rodney Beebe would be recruited to take his place. We launched the boat at precisely 3:15 p.m. We would hunt for only an hour and forty-five minutes.

The twenty-mile-per-hour northwest wind and the rising high tide meant that we'd have a fair shot at divers, though the only ones we'd seen had been the handful we had fed that morning. Aside from that, we'd find fair sport with the occasional late-afternoon black duck and almost certainly of pass shooting some buffleheads. The morning's goose decoys were replaced by a mixture of a couple dozen scaup, redheads and canvasbacks in the scow. Six hand-carved buffleheads, each packed in separate burlap sacks, were placed in the stern to ensure safe transit. With not much time to gun, I elected to head up to Deep Hole Gut. Our fixed box blind would be quickly accessible and somewhat comfortable in the increased wind and colder weather. The right-to-left wind would prove to be very beneficial.

The run to the blind was quick and easy, holding the fiberglass scow tight to the bank of the state marsh. In short order, I nosed the bow of the boat against the reedy shoreline, and Beebe hopped out. We tossed the cased guns and shell boxes ashore, and he set about getting the blind in order. I eased the boat off the bank with mild reverse thrust, Bill began to toss the black ducks in the mouth of a small gut to the windward side of the blind. From experience, we knew that blacks liked to swim into that location. The divers went out quickly, leaving a "power alley" right in front of the switchgrass blind. The buffleheads were placed in a knot downwind and just inside the divers. We figured they'd be coming anyhow and certainly didn't want them to get in the way of a possible shot on divers.

We ran the scow through the blacks up the small gut, and it was tied to a stob around the first bend of the creek. There she would be hidden from birds approaching low from the larger waters of the bay. Bill lept over the bow before the engine had been shut off, whipped a half hitch around the stob and covered the forty yards to the blind faster than he did back in his football days. As I placed the camo cover over the Yamaha's engine cowling, I found out just why he had moved so quickly. Four shots rang out; three canvasbacks lay in the power alley. Upon my arrival, the scenario repeated itself time and time again. For forty-five minutes, we were blessed with shot after shot on the crimson-headed, sloped-billed "Congos." At 4:45 p.m., we elected to pack it in. We had a bushel basket full of game.

The decoy retrieval and ride home went very quickly. At the ramp, the boat was quickly loaded onto the trailer; we were back at the house within five minutes. Once on our property, I grabbed the fowl from the boat, and Bill and Beebe picked up the guns and gear. We headed for the barn.

My father and both grandfathers had just finished building a barn behind the house. Painted red with white trim, two stories with gable construction, it was a very beautiful structure. Once inside, I hung the canvasbacks by their bills on small nails from the rafters of the ground floor. They stretched across the interior width of the barn. The guns were quickly cleaned, and we parted ways. No plans were made for a return trip.

Just as we began to pick at the Thanksgiving leftovers, there was a knock at the door. Dad went to answer it, as I was having difficulty deciding between the turnip greens and dumplings. I could tell by his tone that something wasn't quite right. Bouncing out the door from the kitchen, I nearly spilled my plate. There stood federal game warden Bill Richardson in my living room. He and my father were having some kind of discussion about Ward Brothers decoys. I was pretty sure that wasn't why this fella

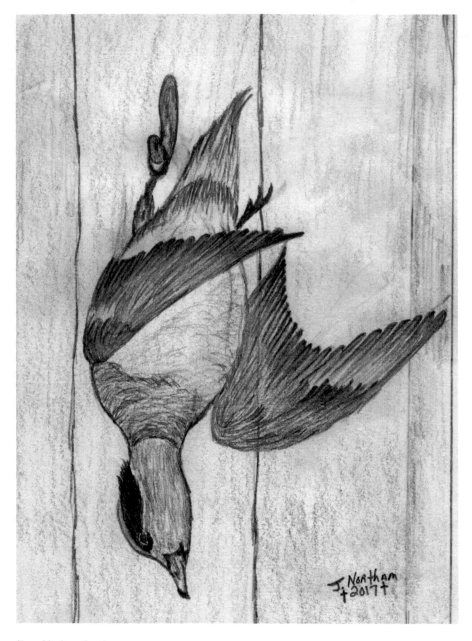

Joyce Northam drawing.

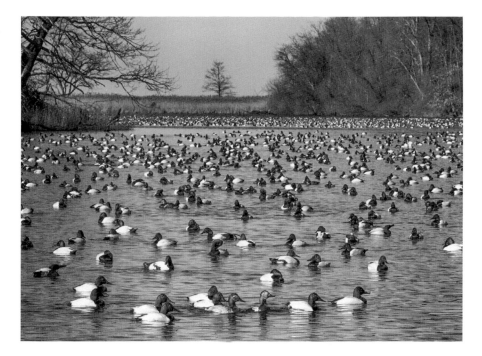

Climate shift has significantly affected the migration pattern of divers like canvasbacks. Once a regular November arrival, lately they have been making a late January appearance. *Paul Bramble photography.*

from Cambridge, Maryland, darkened our doorway on a Thanksgiving night. I cordially asked if he'd like a soda. He declined. I sat down at the table and tried to eat. I certainly wasn't about to get involved in that conversation if I wasn't invited.

After the perfunctory conversation about decoys, he began to unleash a barrage of compliments on the construction of that barn. He elaborated on how beautiful it was, how he wanted to build one just like it and how he was still indecisive about how he wanted the roof. For fifteen minutes he queried my father about the barn. Several times he stopped just short of asking to take a look inside. He could have talked for hours. Consent to look inside wasn't going to be volunteered. The last thing we needed was for him to see those fifteen cans hanging on the rafters. Finally, mom came out of the kitchen holding a pair of plates and announced to my father that his dinner was ready. I'm pretty sure that he, like myself, had lost any appetite that we may have had when this fella appeared at our living room door. With that, he excused himself by saying that he'd try

to stop by on Friday to take a better look at the barn in the daylight. We were glad to see him leave.

After dinner, we made sure that the barn was locked. By legal shooting on Black Friday, those birds were long gone from that barn, replaced by a legal limit of black ducks and green-winged teal by 10:00 a.m. Fortunately, he must have been called elsewhere on that Friday.

THE JULIO STAND

S tarting a new job in a new town is always stressful. Not knowing anyone in the new town adds to the stress. That's exactly the situation I found myself in as I moved to Harrisonburg. I'd left the safety of the Eastern Shore in exchange for the mountains of the beautiful Shenadoah Valley. It would prove to be a very good experience.

Apparently, my reputation as an avid hunter and fisherman had preceded me to the new job. My first job in the poultry plant was one befitting someone who had absolutely no experience in the business. I started as a live hanger. There were a couple of things that I really liked about the job. One was the fact that it started early. Our team of six were among the first to arrive at the plant each day. We were also the first to leave. There was no work to take home, there were no late-night phone calls. When we walked out, we were truly done. There were several very disgusting things about the job, as well. It entailed hanging live chickens by their feet on shackles that would carry them thoughout the first part of the processing plant. With their feet up in the air, we were prime targets for chicken excrement, often forced out under high pressure. It was a dirty, nasty job.

I got to know this fella whose primary job was to remove the feathers from the freshly killed chickens. If there was ever such a thing as a "redneck gentleman," Harold Breeden was one. Living and growing up on Naked Creek, he took a liking to me, and we went turkey hunting a couple of times. He always wanted to split up, which was fine with me. On each of the first two trips, he returned with a turkey. I didn't see one, hear one or smell one.

Though we hunted in the same general area, I never did hear him shoot. On our third trip, I refused to split up. Walking out of the woods, just beside the railroad tracks, there lay a turkey, flopping on the ground. He just walked up to it very casually, which was contrary to all things that I'd ever done. Apparently, excess corn had been spilled around the small grove of oak trees a couple kernels contained 4x bluegill hooks, crimped to 100-pound leader material, with the tag end crimped to a nearby tree. He just walked over to the turkey, wrung its neck and walked out of the woods like most folks walk out of the Walmart.

Over the summer, I found some folks with fishing interests. We regularly fished the Shenadoah for smallmouth and largemouth bass. Other rivers were tried, but our greatest success was found on the north fork of that river. As summer began to draw to an end, I was approached about the subject of bow hunting by my fishing buddy, Bill Miller. Bill was a Carolina boy, having grown up on the outskirts of North Wilkesboro. He shared my love for all things outdoors. He was a quiet type, intensely loyal. Thinking it would be a pretty cool thing to do, I went with him to the local bow shop. In short order I had selected a bow and had it fitted with sights, a rest, a peep hole and several other things I was told I needed. We planned to shoot the next day.

With new bow in hand, I showed up on time at Bill's house. He helped me sight it in and offered tips on how to shoot a compound bow. What little experience I had was limited to long bows in the Boy Scouts and in various phys-ed classes through school. This was a whole new world. We shot every day after work when we weren't dove hunting. I found my maximum range to be thirty yards, a distance at which I could consistently put all shots within a six-inch paper plate. We began to talk about the archery deer season, only a couple weeks away. He had a spot up near Front Royal that he said was one of the best spots he'd ever hunted. He said he'd allow me to build a stand up there. We planned a trip up there on Saturday to check it out.

Upon our arrival, it was easy to see why he liked the place so much. There at the junction of Shenadoah National Park and the Blue Ridge Parkway was an apple orchard. We drove around the edge of the orchard to get the lay of the land. Deer were bedded down in the tall grass throughout the orchard and remained unstartled by our arrival. It wasn't until we exited the truck that they began to scatter. Grabbing a couple of cold beers, we eased into the woods. Just off the inside corner of the field we came upon Bill's stand. It was just what you'd expect a mechanical engineering graduate of NC State to have constructed. It had tight corners, was caulked and was of surperb construction. It sat on the southern side of the inside corner,

just inside the woodline. Sitting in it, sipping on a cold beer, I saw that it provided exceptional shooting access to over half of the orchard. The trails coming from the forest on either side of the cantilevered structure were truly impressive. After a little housekeeping, the stand was ready to go. We went about finding a spot for me to set up. Anywhere looked find to me.

After walking a couple hundred yards, crossing a small creek bed, we were just about to hike up the next ridge when our path crossed the junction of four deer trails coming off the mountain. They formed a deer superhighway heading from a thick bedding area on the side of the hill, past a pair of strong oaks and into the orchard. The pair of twin oaks is where I'd make my play. After surveying the situation, we developed a list of supplies needed and made our way back to the truck. Over the course of the week, the supplies were ascertained and plans made to return the following Saturday to construct my stand.

On Thursday, it became clear that Bill wouldn't be in attendance on Saturday. Personal business would take him back to Wilkesboro. I planned to make the trip alone. I'd built dozens of duck blinds, so I didn't think it would be much of a chore. After several hours of hammering, sawing and ciphering, a stand was nestled between the two oaks from which I could hunt. A wooden ladder provided access to the perch some twelve feet off the ground. After a little cleanup, the gear was quickly loaded and I was off to Harrisonburg, content with what I'd constructed. The following Saturday, bow season opened in the commonwealth. I was looking forward to it.

Bill and I returned the following Saturday morning. Walking in together, we split up at his stand; I continued to mine. I'd never been bow hunting. I also had little experience at hunting in the hills and hollers. It would prove to be quite a new experience. Settling in the stand, things got underway quickly. Just after the sun crested over the orchard to the east, my first visitor came ambling down the hill. The smallish doe was walking down and stopped about forty yards from me on the side of the hill. Her position on the adjacent hillside equaled my elevation. We looked at each other, and she quickly split. On her heels was a larger doe, mostly likely her mother, which followed a lower line along the hill. She stopped broadside at twenty-five yards. With my heart pounding so hard I could hear it, I drew the bow. Controlling my breathing, I steadied myself and took aim just along her backbone. Accounting for elevation and drop, I felt good about my aim and let the arrow loose. Barely grazing the back of the deer, the arrow stuck a pine tree dead center. The old doe skittered down the hill toward her waiting breakfast.

Including that opportunity, I drew the bow three more times before finally connecting an intended target. A fat groundhog made his way from the creek bottom to the left toward my stand. Frustrated from four consecutive misses, I figured I'd give the whistle pig a try. She slowly found her way to the log directly under the stand. Shooting nearly down on the furry beast, the arrow found its mark, striking just behind the head and between the two front legs and pinning it to the log on which it was walking. After a few pinwheels, the animal lay still, pinned to the log by the arrow.

With two more arrows in the quiver, I resumed the hunt. Following the same line as the large doe earlier in the day, the "basket rack" six-pointer stopped in nearly the same spot. Shooting from a sitting position this time, I drew, aimed and set the arrow free. En route, it glanced off a twig protruding into the shooting lane. The collision redirected the arrow, which fell short of the target. Quickly re-nocking my final arrow, I put little thought into the final shot. Almost instinctively I drew, aimed and sent my final arrow toward its target. It connected just above and posterior of the front shoulder. The buck ran, most of the time on three legs, toward the orchard and collapsed in an apple tree just on the other side of the road that borders the farm.

After collecting my emotions, I climbed down to retrieve the arrows that didn't find their mark earlier in the day. The one that pinned the whistle pig to the log broke when I tried to pull it out. The one that felled the deer was also quickly found. The other four would be MIA. With that, I walked out of the woods and met Bill at my deer. He had seen it crash from his stand and came over to congratulate me. I was quite excited. After field dressing the deer, I took the hike to fetch the truck. Upon my return, Bill wasn't at the site where I had left him. His bow and backpack were propped up on the deer's back, alongside my gear. I could hear him laughing uncontrollibily back under my stand. I walked over to see what the commotion was all about.

He sat on the log, beside the groundhog, staring up at my marvel of engineering. For the next twenty minutes, I sat there taking verbal barbs, one after another, about my lack of carpentry skill. It wasn't the most pretty stand I'd ever seen, but it was functional. He asked me, "Just who in the hell helped you build this thing? Julio from Accounting?"

With that, the name stuck. From that point on, it was given the moniker "The Julio Stand."

UNANSWERED PRAYERS

Sitting at the desk in downtown Salisbury, I stared out the window at as fine a Delmarva summer Saturday morning as God had ever made. My thoughts were on only one thing: fishing. My four-hour Saturday morning shift would be over soon. At precisely 1:00 p.m., I'd be locking up and heading south.

The combination of gentle southerly breezes and late June weekend sunshine held my attention most of the morning. My wife and I had made plans for an afternoon fishing trip to the shallow-water rock piles off Saxis. Trout, croakers and the occasional black drum were being taken with regularity. Bottom fishing with light tackle adorned with chunks of peeler would be the method of choice. It's a relaxing way to spend such an afternoon.

It wasn't a very productive workday, especially since my wife's new acquisition was sitting at home in the driveway. We'd been to Bob's Marine in Clarksville to look at a slightly used center console. It was within our budget, and I wanted it, but our money was tight. We figured we'd just wait. My wife didn't share that opinion. Without my knowledge, she pulled the trigger on it, towed it home and had it sitting in our driveway as I returned from work on an otherwise very typical Tuesday night. Needless to say, it was quite a surprise. Aside from a few "booze cruises" on the Pocomoke River, we hadn't had the chance to take it fishing yet. This was to be the day.

At precisely 12:55 p.m., the phones were turned to the answering service, the doors were secured and my Toyota was pointed south. While en route,

calls were made to secure peelers. The required tackle was awaiting pickup at Sea Hawk. We had planned this trip the night before. Prior to leaving for work on this sun-filled Saturday, the boat was latched to the truck, rods were stowed and a packed cooler sat waiting for us in the garage. We would simply change clothes and leave land behind.

In short order, we were rolling southward, boat in tow. A quick stop at Sea Hawk for tackle and ice, and we were on our way. As we made to the west on VA Route 695 toward Saxis, Cheryl made mention of the darkening skies to the south. Having checked the radar prior to leaving the house, I confidently explained to her that these storms would pass us far to the south. I reassured her that we had nothing to worry about. With that fear allayed, we cracked our first beverage of the day and eased down the turtle-backed road toward the ramp.

Like a kid in an old-fashioned parade, I made my way through my hometown of Sanford, new boat in tow. I was proud as a peacock of our new purchase and equally as proud that my wife understood my outdoors addiction. We were going fishing. Things couldn't have been better.

Rolling down Hammocks Road, I quickly noticed that the tide was in our favor. I've always favored fishing the first of the ebb. We were right on time. The boat slid effortlessly off the trailer and into the last of the incoming current. The truck was quickly parked illegally. As I proudly strode toward the boat, my wife awkwardly holding the bowline as the boat's stern gently bumped a downtide piling, I couldn't contain my excitement. This day was to be spent together on the calm waters of the Pocomoke Sound catching fish and enjoying a perfect Delmarva day.

The Johnson 150 roared to life. After a short and smoky warm-up, the command was given to cast off. It was the first boat I'd owned with hydraulic steering, and both times I'd used it to this point, I'd been amazed with the difference between it and the Teleflex I'd become accustomed to. It was certainly an advance over the tiller stick operated by ropes and pulleys that I'd commercially used in my youth. Just prior to bringing it up on plane, Cheryl made mention of the storm clouds looming to the south. Again I assured her that we were just fine. Bringing it up on plane, we quickly accelerated to thirty knots and gloriously made our way toward Marshall's Rock. What else could a Shore Boy ask for? With a cold beer in hand and a bathing-suit-clad blonde as copilot, heading toward one of my favorite fishing haunts in our new boat, I was in a perfect place.

About three miles from our destination, just about halfway out of Messongo Creek, the mighty Johnson sputtered, choked, spat and finally

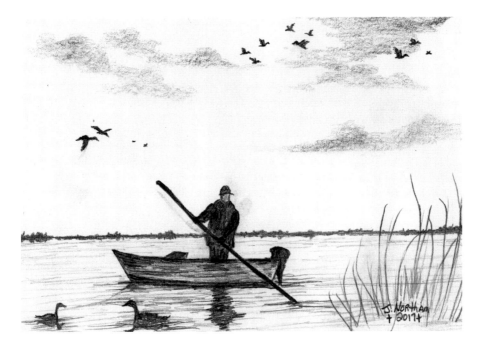

Joyce Northam drawing.

quit. There we sat aboard our new rig, cranking and cranking to try to get this thing running. Everything indicated that we were out of fuel, but that couldn't be right. The fuel gauge read half a tank. Quick calculations in my head began to raise questions. The only conclusion was that the sending unit was broken. We drifted along out of fuel. Our day of relaxation took a turn for the worse.

Calls on the VHF went unanswered. I did manage to raise one of my buddies on the cellphone, but he was in Annapolis and wouldn't be able to offer assistance for at least a couple of hours. Sitting there drifting along was fairly peaceful. We had beers to drink, and I assured my wife once again that we would be fine, someone would would be along shortly and those storm clouds hadn't in fact drawn closer to our position. I firmly believed the first two affirmations. That last was a bald-faced lie. The storm cell had, in fact, changed course. That lie was revealed in less than ten minutes, as what started as a gentle breeze now stiffened and the bay was turned to a small chop. The passage of five minutes brought us rain and another five knots of wind.

Not having a pole, paddle or oar at my disposal proved to be a real issue. We were only a couple hundred yards off the windward bank of Free School

Marsh. The twenty-knot south wind pushed us quickly toward the marshy shoreline, but as the lightning began to strike toward Watt's Island, we felt increasing pressure to be somewhere along the soft soil. Paddling with cooler lids and the top of a tool box, we made it to the shore, where my first mate quickly jumped off the boat and was up to her knees in Saxis Island marsh mud. The two-foot chop slammed the boat against the mud-and-mussel mix as I tried somewhat successfully to hold the boat off of the bank. My wife tried to help hold the stern off the bank, all the time letting me know how lucky she was to be married to me.

Luckily, we hit shore just near a small cove. After battling the broadside waves for only about one hundred yards, we brought the boat stern-to the waves, making the next one hundred yards somewhat easy. That small reward was welcomed. The storm intensified. The rain was torrential. Lightning danced across the water near Lower Bernard. The concurrent clap of thunder wasn't heard, it was felt. On the radar, we were right in the red. It couldn't have gotten much worse.

The next strike of lightning danced across water near Cambodia, a mere four hundred yards from our windward cove. Striking that close, the thunder was almost instantaneous. The reaction from my wife was not at all predictable. It scared the crap out of me; it put her over the button! She'd been given the task of holding the stern line as I guided the bow down the bank. As the tunderous clap resonated through our bodies, she immediately dropped the line and went on a rant. She certainly deserved it. I suppose I did, as well.

Informing me that she was now done with trying to keep the boat off the marsh, she also informed me that she was now going home and began to quickly walk toward Hammocks Road from the shoreline. She started straight across the marsh. I thought she wouldn't have that tough of a walk and stayed with the boat. Lightning struck near Dicks Point. Turning toward me, she was standing knee deep in mud and marsh grass. The next few seconds will forever be emblazoned in my mind.

Raising her hands to the heavens and looking skyward, my wife uttered the following words, "Please, God, strike me dead so I don't have to live the rest of my life with such a stupid son-of-a-bitch!" With that, she turned and hightailed it toward Hammocks Road.

All I could do was laugh.

WEIGHED AND MEASURED

The chance to win a couple million dollars isn't something that comes along every day. Well, actually, it occurs each year just fifty-eight miles from Saxis, Virginia. The White Marlin Open is held the second week of August each year and is arguably the busiest week of the crazy summer season. We figured that we'd have as good a shot as anybody as we plunked down our entry fees and Calcutta money.

As weekend warriors, we had been blessed with great success during the fishing season. It had started early as a good warm-water eddy moved into the Baltimore Canyon in late May. There, the first white was caught much earlier than in most years. We had battled many yellowfins and the occasional white during that early bite. June brought us strong numbers of bluefins in Massey's Canyon. We fully exploited this opportunity due to its close proximity to the Ocean City inlet. It was a very easy go and relatively inexpensive compared to most offshore ventures. In late June and through July, our aim was firmly fixed on increasing numbers of yellowfins and billfish found just inside the Washington Canyon. We had a system that was working for us, and the fish were willing. Our small, amateur crew felt confident looking into August.

Rolling into August, we watched as good, clean water moved into the Norfolk and was predicted to slowly move northward and a bit more offshore. Anthony Thomas's North Coast 32, aptly named the *Sea Horse*, had been our ride for this busy season thus far, and we hoped it would carry us to the promised land during the open. Bill Hall, Brian Lewis and mutual friend

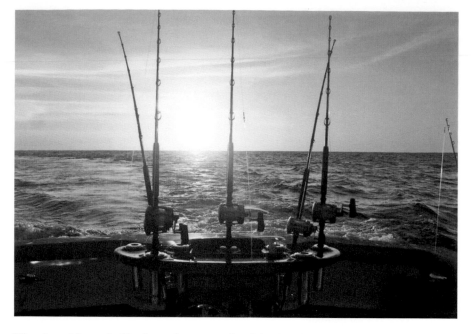

There's nothing quite like the excitement and anticipation that the dawning of a new day brings while on the ocean. *Jake Graves photo.*

Bill Bateman rounded out our crew. The five of us had fished together on several occasions during the year, with good results. Anthony, Bill and myself had grown up fishing together. Brian is an Ocean City insider and a damn good fisherman in his own right. Bateman, a bit older than we four, was more of a gambler than the rest of us and seemed to enjoy the risk as much as he enjoyed the fishing. Plus, he had a pretty good connection for some outstanding chicken wings that we'd munch all week.

With our entry fees paid, a little money at risk and brimming with confidence, we readied the boat for the week's action. The *Sea Horse* was a very capable boat, recently re-powered before the season. The twin gas-guzzling 454 Crusaders were replaced with powerful Cummings diesels. This engine swap did wonders for the boat. Daily fuel usage was cut nearly in half, power and torque were increased and the fish seemed to like the new sound of the hull and engine combo. Whites seemed to be drawn right to her exhaust. Baits were brined and rigged, new line was put on the reels, all knots and crimps were retied, hooks were sharpened and all of the pertinent gear was examined to reduce the chance of losing a fish due to equipment failure. Though it happens, we did everything in our power to reduce that

chance. Our excitement built as we continued to ready our gear for the pending weeklong battle.

In the open, participants are allowed to fish three out of the five eligible days. The forecast for Monday, the first day of the tournament, was for two-foot seas and light southwest winds. It promised to be an excellent day offshore. Tournament rules state that fishing cannot begin prior to 8:30 a.m. Our plan on the first day was to run to the 461 Pimple and begin moving southward. We'd heard encouraging reports from other boats that had fished that area in the previous two days. It was as good a place to start as any, and we were comfortable there. Our plan was to cast off at 4:15 a.m., giving us ample time to cover the sixty-four miles to our starting waypoint.

None of us had ever fished in the White Marlin Open before. The buzz of activity at the Ocean City Fishing Center on the morning of day one was far different from any we'd ever experienced. This and every other marina in town was full. The best and most well-funded teams from all over the East Coast annually find their way to Ocean City to compete for the cash as well as for bragging rights. Battlewagons and professional crews would be going rubrail to rubrail with rednecks like us. What we lacked in skill and experience we made up for in spades with confidence and local knowledge. More than four hundred boats had registered. We liked our odds. Emphasizing that confidence, we had bright-yellow shirts made with our names on the front pocket. On the back in big, black, bold letters we clearly stated our objective. "Kill Whitey." Those shirts were the subject of numerous discussions along the docks. We really didn't care. We were on a mission.

For those who fish, there is no sensation that compares to the feeling of rolling out of Ocean City Inlet with four hundred other boats during the White Marlin Open. Boats from twenty-five to eighty feet slowly idle toward the "C" bouy as hundreds of onlookers line the parking lot, watching the parade. With towers lit in blues, reds, greens and whites, bobbing with the incoming swells, the procession slowly ebbs seaward. It's a feeling unlike any other.

Our first day of fishing went farily well. We finished our day three for five on whites and managed to put a tuna and a pair of gaffer dolphin in the box. It was fairly crowded out on the little seamount. Being a smaller boat, were at a disadvantage as compared to the factory teams and professional crews that shared our desired location. Our crew was working well together, as expected. On the ride in, we began to strategize on our remaining fishing days. Our decision was to not fish on Tuesday or Wednesday. The weather was a little iffy on those two days and looked to improve greatly at the end

of the week. Our plan was to meet Wednesday night to prep the boat for two straight days of fishing. We all agreed that Thursday and Friday would be our days.

Thursday's trip was much like Monday's. We scratched out a pair of whites out of six looks, jumping off two at the boat. It got increasingly crowded, to the point that it was no longer fun. Fish were being caught in record numbers, but all were on the smaller side. The radio chatter toward the end of the day was absolutely chaotic. Hookups, releases, talk of "You ran over my long rigger!," "Which way are planning on turning, Cap?," and "Grady White, you're going to run over my long rigger!," as well as many unprintable discussions, occurred due to the close proximity in which we were fishing. It seemed as though every boat in the tourney was fighting for the same piece of water. It was agreed that we would stop just short of the pimple before Friday morning's line's in call. Our departure time remained 4:15 a.m. It was getting down to the wire.

Idling across the no-wake zone outside the smallish entrance of the Ocean City Fishing Center, it became obvious that we weren't going to be alone out there. Most of the field had planned, like us, to take full advantage of the good Friday weather. We surmised that, due to their earlier-than-normal departures, they, too, had heard of the good bite "in the deep." Moving into the deeper water of the inlet, we merged into the mass of boats headed seaward. Throttling up in unison and clearing the inlet, captains began to make their courses known. Some headed northward to the Poormans, some south to the Norfolk and most straight out toward the Washington. We figured that a good percentage of those would continue to our common destination. We guessed right, but we had something different in mind.

Anthony pulled the throttles back with thirty minutes to spare before lines in. We were nearly six miles from where we had fished the previous two days. Boat after boat roared past us toward the 461. It was a place that we had no interest in visiting on the last day of the tourney. Our plan was to find our own fish, a little closer to home.

We slowly idled the area looking for the best possible place to start fishing. The riggers were lowered, rods properly positioned and baits rigged and held on ice until they could be legally deployed. The place looked alive. Flying fish skittered across the tops of the two-foot chop. Slicks, signifying predatory fish feeding on fleeing bait, were popping up everywhere. Small schools of baitfish swam just under the surface. The place smelled like fish. As the call for "lines in" came across the radio, the flatline baits were flipped in the water. As I sent the starboard long rigger back, I gave the flatline

baits a glance to see how they were swimming. The pair of naked ballyhoos swam lifelike just fifteen yards behind the transom. While I was working on the starboard short rigger, Bill Hall moved quickly from the port rigger toward the flatline on his side of the boat. After a short dropback, he pushed the drag on the TLD 25 forward. Waiting for the slack to come out of the line seemed to take an eternity. Coming tight, he skillfully set the hook on our first white of the day. The fifty-pound white put on an aerial display as Anthony began a wide turn to that side of the boat while calling in our hookup. Having only one line out on that side of the boat, the odds weren't in our favor of finding a double—and we didn't. After a short fight, the rat white was released at boatside. We were off to a good start. The radio was alive with other boats reporting similar results. We were in the right place.

We slowly circled back to the spot where the first bite occurred. The port flat popped and the line began to leave the reel at a hellish pace. Just as quickly as the bite had appeared, it was gone. We went from elation to despair in twelve seconds. Less than a minute later, it came again. This time, we saw the bite. Rolling on the surface like a compact car at high speed, the bigeye tuna hammered the port shortrigger and then looked to leave the scene quickly. Bill held the rod, which was about all we could do in this situation. We quickly cleared the other lines and began the chase to recapture the three hundred yards of line the fish had taken. Forty-five minutes into the fight, the fish was deep with no plans for surfacing. Anthony tried to coach Bill into putting a little more pressure on the fish. This effort resulted in the fish just getting pissed and ripping off a short burst of line in twenty-yard intervals. As quickly as he appeared, he was gone. It was not a failure of any sort; the hook just pulled out of the fish. Quietly, we reset the white marlin baits. Our first hour had been quite exciting.

The day continued along the same pace. We were catching fish, but were still in search of the right one. Catching a few singles and the odd doubleheader our daily total climbed to eight whites on the day. It sounded like a war zone out on the Pimple. We continued to fish by ourselves. The bite had slowed during the middle of the day. Our discussion centered around the after-lunch bite. The clock revealed only two hours left in our tournament.

The fish came up on the port short rigger and showed minor interest. Before the rod could be pulled from the rod holder, the fish's color changed to a bright neon blue, and it moved quickly to the flatline. Lit up and tailing behind the bait, the line was freed from the tansom clip as the reel was placed in freespool. The bait fell in the open mouth of the fish, just as planned.

When the barb of the hook sunk into the jaw of the fish, the huge white marlin rocketed skyward. The decision was instant. "We're gonna kill that fish," came out of my mouth in a rather matter-of-fact tone. The mood on the boat immediately changed.

It was the one that we had worked all week for. It was broad, long and had "shoulders." We all believed that this one could put us in the money. All due attention was paid to fighting this fish. Bill handled his angling responsibilites skillfully. Brian handled the wiring duties, and my aim with the steel was true. The fish lay still on the cockpit floor of the boat discharging the contents of its stomach. I hoped that the two pounds or so it had expelled wouldn't hurt us at the scales. Measurements were taken and rechecked. Our fish was two inches longer than the seventy-two-pounder leading the tournament. General consensus aboard the *Sea Horse* was that it wouldn't go seventy-two, but it could be good enough for the second or third spot. We elected to haul ass back to the dock.

The fish was properly iced, and every effort was made to keep it hydrated. Once the fish was properly cared for and the gear properly stowed, we began the three-hour trip back to the inlet. Sipping cold beer, we began to discuss how we planned to spend our winnings. At the ten-mile mark from the inlet, we began to place calls to all necessary parties informing them that we'd be going to the scales. We ran out of beer as we made our way through the inlet. Bateman's wife was to arrange for a cooler of beer to be waiting for us at the scales. We ran eight upside-down white marlin flags up the starboard rigger, plus one with the dorsal side up, signifying that we had boated a fish. Tournament aside, it was our best day of the year.

The excitement of what we were about to do built quickly as we took the right at the Oceanic Pier and began a slow jog up to the Route 50 Bridge. Our little thirty-two-foot boat held position against the outgoing tide, waiting for the bridge to open, dwarfed by the fifty-footers headed for their berths at Harbor Island. The radio was alive with chatter relaying information from the scales. Friends inquired about what we had in the boat. Remaining calm was starting to become difficult. The bridge opened and the stern of the *Sea Horse* squatted as the Cummings forward gear was engaged. Taking the right into Marsh Harbor, we waited our turn to check off a bucket list item. We were going to the scales at the White Marlin Open. Holy shit!

We sat silent while waiting our turn. Many of the crowd of four thousand who had gathered around the dock really had no interest in the weigh-in. They were just there for the party. The sixty-foot Jim Smith, *Tin Man's Pride*, pulled away from the dock and hid us in its shadow as it eased out of the tight

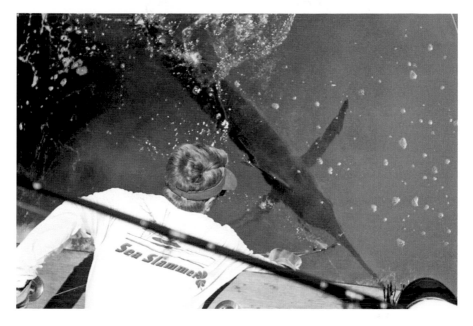

A blue marlin at boatside demands the full attention of the captain and especially the mate. Jake Graves has this one under control as he prepares to set him loose. *DaBait photo.*

egress of the marina. It was our turn. From my vantage point in the cockpit, I could tell that Anthony was nervous. He cracked his knuckles incessantly, and his face took on a look of seriousness. This was serious business. The *Sea Horse* spun around on a dime, and Anthony began to back in to the scales. We had about eighty yards to cover. With about fifty yards to go, I stood on the engine box and slapped on the floor of the bridge, asking him to stop.

"What's wrong?," Anthony questioned.

"Nothing," I replied. "I just wanted to take in this sight and remind you not to screw this up. We may not get here again!"

With that, the five of us broke into laughter and lingered just off the scales for a moment. Our cheering section was large and vocal. When we tethered to the dock, a rather large man with a red sixty-quart Igloo on his shoulder pushed his way through the crowd and delivered our cooler of ice-cold beer. Beers were tossed from the bridge to the crowd. The celebration resumed.

Our fish was weighed and measured. Though long, it was a lean fish. He didn't have the weight to propel us into the money. The plans we'd made over the last four hours disappeared as the weight of the fish flashed on the digital scale. There'd be no polygraph, no check presentation and no

interviews. Just a couple of pictures at the scales and in no time we were on our way back out of the marina, wondering what might have happened if the fish had held on to its stomach's contents.

We may not have won any money, but it's arguable that we had more fun than most.

FIVE MINUTES OF FURY

One might think that there is quite a difference between shooting wood ducks in the swamps of Delmarva and hunting blue marlin on the seamounts off Los Sueños, Costa Rica. The truth is that they really aren't that much different. Both entail long periods of intolerable boredom interrupted by short bursts of absolute chaos. It was that chaos that Jake Graves and I were chasing on a crisp October morning.

Jake had been on a long stretch of fishing on the Da'Bait, down on the Pacific coast of Costa Rica. The primary target is live-baiting Pacific blues around various seamounts and fish-attracting devices. Such variation in the seafloor creates a perfect situation to collect baitfish. That in turn holds good numbers of pelagic fish. At the top of the food chain sits the bully of billfish, attracted to the area for the easy pickings. They're quite accomplished at catching them. Through the eyes of many, the pictures on social media show a young man who is "living the dream." While that may be true, the hard work it takes to stay at that level goes unseen. Living and working in a third-world country nearly two thousand miles from home can take a toll on a person. On a two-week hiatus from fishing, Jake headed home for a little waterfowl hunting. I was glad to have him in the blind.

We had hunted together many times. Part of the enjoyment of a hunt is knowing what to expect from your hunting partner. We'd be in a pond, woods, open water and fields for ducks, geese, deer, turkeys and doves. If there is a season for it, we had killed it. The results of this morning's

hunt really didn't matter. Jake had traveled a long way to go hunting. Just going through the process would be sufficient to call it a good trip. Pulling the trigger would be a bonus. A full moon, light winds and clear skies would make for a day difficult to grind on the ducks, but we'd take what we could get. It was just good to be able to go.

He arrived early at the arranged meeting spot. As I topped off the twelve-gallon gas tank in the aluminum johnboat, he emerged from the Goose Creek store with coffee, a fresh tin of Copenhagen and a pair of breakfast sausages. Milo got the better end of the deal, eating half of Jake's and most of mine. The coffee was reserved for human consumption. On the way to the ramp, we chatted about his recent fishing endeavors and more about the prospects of the day's hunt. We both agreed that if we were to get any action, it would be early. We'd have to capitalize on every opportunity.

There would be no competition from other hunters on this day. Our's was the only truck in the parking lot as we eased away from the dock and began to make our way southward down the Pocomoke River. Arriving at

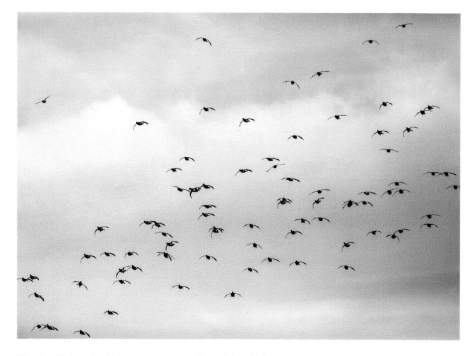

For the diving duck hunter, scenes such as this will forever be etched in the mind and be recalled vividly in the imagination. *Paul Bramble photography*.

the blind three-quarters of an hour before legal shooting, we haphazardly tossed six wood-duck decoys in pairs to the right of the blind in the widest part of the creek. The half dozen teal were placed in the shallow waters of a mudflat at the mouth of a small feeder creek. The boat was hidden around the point, and we readied ourselves for the morning's shooting. We felt as though it would happen early.

As we intermittently checked our phones for the time, the marsh began to come alive. With the first discernable rays of light, the pair of bald eagles departed their nest, just to the left of our blind, in search of breakfast. The shrill whistle of woodies scattered throughout the marsh on this high tide and the chatter of marsh hens broke the stillness of the morning. The sound of wings was very audible as teal and other summer ducks began stirring. Legal shooting came and went without incident.

A pair approached the blind from the rear. They quickly banked to the right and found their way into the wood-duck decoys. We rose in unison, and the pair were handled efficiently. As Milo entered the water, a single, flying on a low direct path, made a fatal decision. Jake tumbled him into the marsh just behind the blind. On her return with the first bird from the water, Milo was dispatched to the bird in the marsh. With those two in hand, she returned to the unfinished business floating off in the ebbing tide.

As she was nearing the halfway point on this retrieve, three very vocal wood ducks cleared the cypress trees to our left and flew without hesitation toward our decoys. There was no circling, no calling, no waiting. They darted from left to right and danced like marionettes as they caught wind in their cupped wings. We took them on the pass. Our five shots left the three floating feet-up on the slick surface of the water. Our limit was complete in less than five minutes. But the bag wasn't the highlight of the day.

The highlight was the joy that shone in the young Graves's eyes during this five minutes of fury. The action ended just as quickly as it had begun. Six came to the decoys and six stayed, now placed in a sloppy pile behind our thatch blind. There was no need to stick around for the occasional puddle duck. It was over for this morning's hunt. But in the five minutes that the birds flew, we took full advantage of what the duck gods gave us.

For those who venture into the marshes in seach of ducks, there is no substitute. No fish, no deer and no other form of hunting can replace the experience of standing in a salt marsh watching as migrants from the far

north fall in, committing to the decoys. The shot and the retrieve, and silently recalling the feel, smell and sights of the morning's adventure, are similar to other outdoor endeavors. But there's something about living in those five minutes of fury that sets it apart from everything else.

THE WRECK OF THE
SOUTHLAND

The day began like many had before it: early. It was the tail end of another oyster season, and the *Southland* cleared the mouth of the James River, rounded Stingray Point and began to make her way up the bay toward Crisfield. The boat was heavily laden with barrels of seed oysters, and Captain Carroll Lee Marshall and his mate, Edward Corbin, looked forward to completing this last long trip of the season. Crabbing was just around the corner, and it was time to get ready for that summertime endeavor.

The trip would be blessed with warm weather and a following sea. Morning temps were a crisp forty-five degrees, and the midday sun would warm the decks of the forty-eight-foot *Southland* to sixty-five degrees. The warm, fifteen-mile-per-hour southerly breeze would push it up the bay, quickening its fifty-four-nautical-mile journey. If all went well, it would average ten knots, and they'd share supper in the safe confines of Somer's Cove.

The *Southland* was powered by a single engine that worked most of the time. This trip had been plagued with one engine issue after another, greatly delaying their arrival. Marshall and Corbin combined mechanical skills to keep it running. Midmorning brought them past the mighty Rappahannock, and the *Southland* was running perfectly. With the sunshine on their backs and wind in their faces, these two men were enjoying the day and celebrating their last oyster seed-buying trip of the year. With any luck, it would be late September before they would have to make this trip again. Summer was coming; for Marshall, that meant warm evenings spent with his wife, Naomi, and his three young children.

Naomi and her half sister Madge were among the last residents of Watts Island. Watts, located between Tangier and Onancock, provided a sparse but joyful upbringing for the two sisters. Several families occupied the tiny spit of land in the middle of the bay. School was taught by the elders, regular playmates included domesticated animals and basic entertainment consisted of progging for interesting artifacts. The girls shared many hours watching sailing ships drift by the island and off into the horizon. News from the outside world was garnered at the Doremus home, where tales of the sea and many fantastic "supernatural epochs" were spun. In 1907, they left the island. Naomi met and married Carroll in 1919. Madge spent her youth modeling in New York before retiring back in Saxis.

As the sun set in the western sky, the *Southland* made its way toward Tangier Island. Dinner was a welcomed treat, relishing the cold meat sandwiches as they watched the tree-lined shores of the Rappahannock fade in the distance. Soon, they would be able to see the twinkling lights of Crisfield. The south wind had increased in intensity; gusts now reached twenty-five miles per hour. In the deeper waters of the Tangier Sound, the rollers began to slow the progress of the heavily loaded boat. They were on the downhill run into Corbin's hometown of Crisfield. Offload would occur in the morning, after which Carroll would return to Saxis on the *Southland*. Now nearing three o'clock in the dark, windy morning, the engine again began to sputter.

Before the two mariners went below in an attempt to remedy the problem, they made certain that their lights were working properly. Below, they cussed the two-hundred-horsepower diesel for its ineptitude. They drifted beam to the seas just off Fox Island Bouy on the eastern edge of the Tangier Sound.

The three-masted schooner *Lorena Clayton* was also making its way up the bay toward her home port of Cambridge. Captain John Conoway was at the helm with a crew of three as the 120-foot craft cut the night air with the aid of wind, tide and waves. His first view of the *Southland* was its lights disappearing under his sharp bow, followed by a horrific collision. In the dark, he could not discern the name or make of the boat he was about to destroy. There was no time to avoid the collision. He went hard port rudder in an effort to shed his hull of the *Southland*.

Conoway brought his vessel about, returning to the shards of wood that littered the waters. Through the darkness, cries of "Help! Help me!" were heard as Marshall and Corbin struggled to stay afloat in the fifty-degree water. Conoway ordered a yawl (small lifeboat) lowered into the water along with a crew of two men in an attempt to rescue the two men floating off in the night with the incoming tide. The relentless waves lashed the side of the

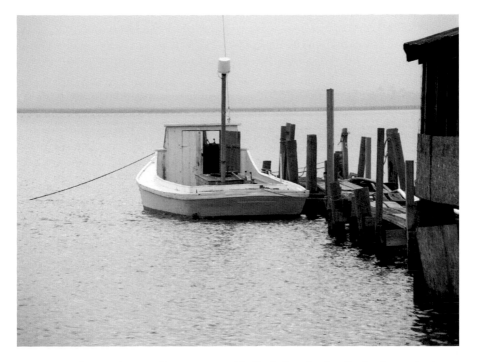

Chesapeake Bay deadrise workboats are specifically designed to handle the demands of working on the water. This old, round stern has certainly seen its share of calm days and heavy seas. *Jim Lewis photo.*

yawl, nearly filling it with water. They bailed frantically, but the waves and spray continued their intrusion into the yawl's engine and battery terminals. The small rescue boat was put out of commission. Conoway made the decision to anchor at the site of the crash for the night.

By the dawn's early light, a body was seen clinging to the top of some floating wreckage. The wind continued to make any rescue difficult, if not impossible. The yawl was again put into service, this time successfully. The yawl made its way to the floating debris, and a rope was tossed to Corbin. Weak from the night's ordeal and chilled from a night in the bay, he took the rope and was dragged through the water to the safety of the boat. Weak and cold, his grip gave way and he slipped below the surface of the water. Rising again on the other side of the yawl, he again was tossed the lifeline. His last efforts were in moving toward the rope before succumbing to the bay's wrath. Sinking below the waves, all hope was lost. Retrieving the small boat, Conoway called off the search and made way to Crisfield.

The body of Corbin was never recovered. The body of my great grandfather, Marshall, was found in Cedar Straights, just northeast of Great Fox Island, forty-four days later, on May 8, my father's birthday.

Naomi was left with three young children to raise on her own. One can feel her anguish reading the words she penned in the spring of 1925.

The Wreck of the Southland

On one cold stormy March morning
The waves were dashing their spray
The Southland came out from harbor
Winding her way down the bay.
Two were on board the Southland
They knew nothing of their sad fate
That did soon overtake them
Carroll, my husband, and Edward, the mate.
Then suddenly a crash came upon them
By a schooner with sails unfurled
Ran over the Southland so quickly
That to the bottom she soon was hurled.
Seven weeks their bodies lay in the water
The Southland was never yet to be seen
And oh, my friends give me pity
If it had only been a dream.
I'm left with three little orphans
The heartaches and burdens to bear
But I'm trusting a friend though unseen
He my burdens with everyone share.
And some glad day tomorrow
When these heartaches are o'er
I trust we'll meet where there's no sorrow
And dwell there forever more

—Naomi Drewer Marshall

ABOUT THE AUTHOR

C.L. Marshall has shared his passion for hunting and fishing on the Eastern Shore since his days in the mid-1980s at the *Eastern Shore News*. Many of these stories were shared in his last book, *Chesapeake Bay Duck Hunting Tales*, which was acclaimed by the National Rifle Assocaition as a glimpse into the "then and now" realties of waterfowl hunting.

A former editor of *Shore Golf Magazine* and *The Fisherman Magazine*, Marshall works hard at experiencing the best that the Eastern Shore has to offer. He is at home chasing divers in the frothing whitewater of the Tangier Sound or tricking a billfish into snapping up a dead baited ballyhoo. If there's a season for it, you can bet he's chasing it.

His other works include a pair of cookbooks, *A Taste of Eastern Shore Living* and *A Taste of Delmarva Living*. To find out more about Marshall and his upcoming events, check out his website at www.clmarshallpublishing.com.